PHOTOGRAPHING FRIENDS AND FAMILY

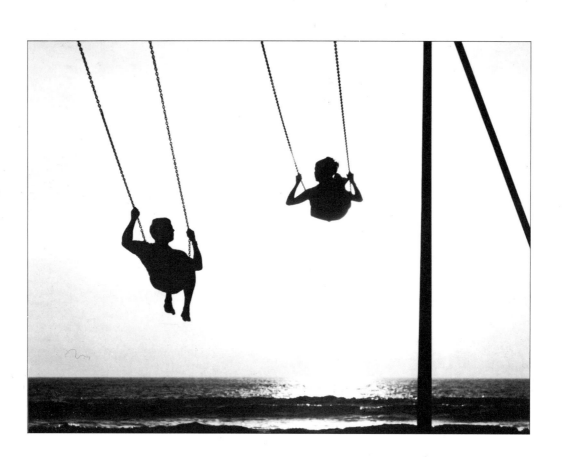

PHOTOGRAPHING FRIENDS AND FAMILY

Published by Time-Life Books in association with Kodak

PHOTOGRAPHING FRIENDS AND FAMILY

Created and designed by Mitchell Beazley International
in association with Kodak and TIME-LIFE BOOKS

Editor-in-Chief
Jack Tresidder

Series Editor
John Roberts

Art Editor
Mel Petersen

Editors
Ian Chilvers
Louise Earwaker
Richard Platt

Designers
Robert Lamb
Michelle Stamp
Lisa Tai

Assistant Designer
Susan Rentoul

Picture Researchers
Brigitte Arora
Nicky Hughes
Beverley Tunbridge

Editorial Assistant
Margaret Little

Production
Peter Phillips
Jean Rigby

Written for Kodak by Tony Scott

Coordinating Editors for Kodak
Kenneth T. Lassiter
Kenneth R. Oberg
Jacalyn R. Salitan

Consulting Editor for Time-Life Books
Thomas Dickey

Published in the United States
and Canada by TIME-LIFE BOOKS

President
Reginald K. Brack Jr.

Editor
George Constable

The KODAK Library of Creative Photography
© Kodak Limited All rights reserved

Photographing Friends and Family
© Kodak Limited, Mitchell Beazley Publishers,
Salvat Editores, S.A., 1983

Library of Congress catalog card number 82-62975
ISBN 0-86706-206-1

Contents

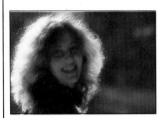
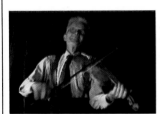
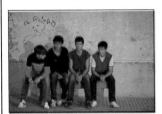
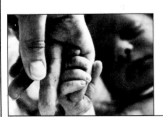

PICTURES OF OURSELVES

The first pictures any photographer takes are likely to be of family or friends. Whether good or bad photographically, they have a personal meaning that grows as time passes. Such pictures can make us laugh – or cry – because they record our own lives. In a real sense, they are pictures of ourselves.

Nevertheless, in every album there are some pictures that we look at more often and with more pleasure than others. These images may be brimming with life – the gap-toothed grin of a six-year-old – or utterly quiet – the frail face of a loved grandparent. But their special quality is that they seem to place us in direct contact with the people we know. They reflect the fact that a photographer who is familiar with a subject can reveal insights impossible to a casual observer, and capture moments that could never be staged.

All the pictures on the following nine pages have this direct emotional impact, and the impression of having been snatched from life. Many of them were taken by relatives, and all by photographers who personally were close to the subjects. Yet strong, spontaneous pictures such as the one opposite are comparatively rare. Although friends and family are the most convenient, as well as the most changeable and fascinating of subjects, they also can be among the most difficult to photograph well. The aim of this book is to suggest ways of avoiding pitfalls, so that you can take pictures of your family or friends that have qualities as good photographs – as well as being records of your own life and times.

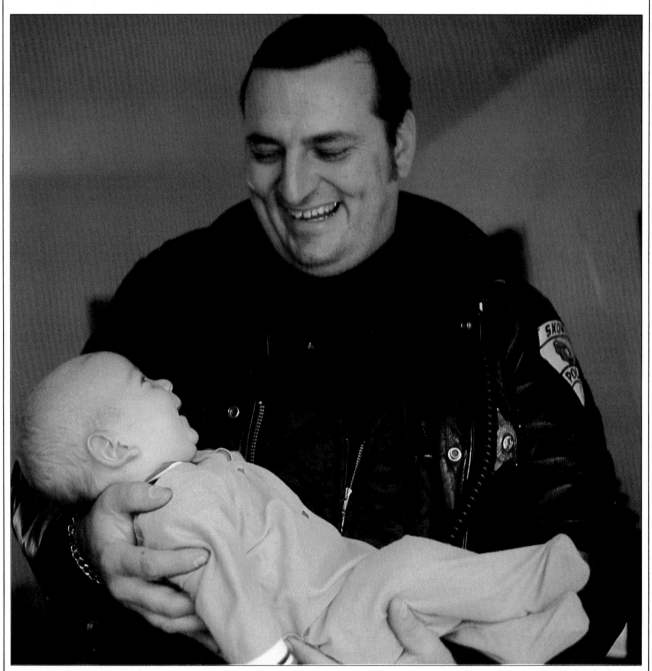

A burly police officer with *his baby shows the power of a simple, direct portrait. Their mutual delight is heightened by contrasts – between the father's leather-jacketed toughness and his gentle pride; and between his big hands and the tiny body he is cradling so securely.*

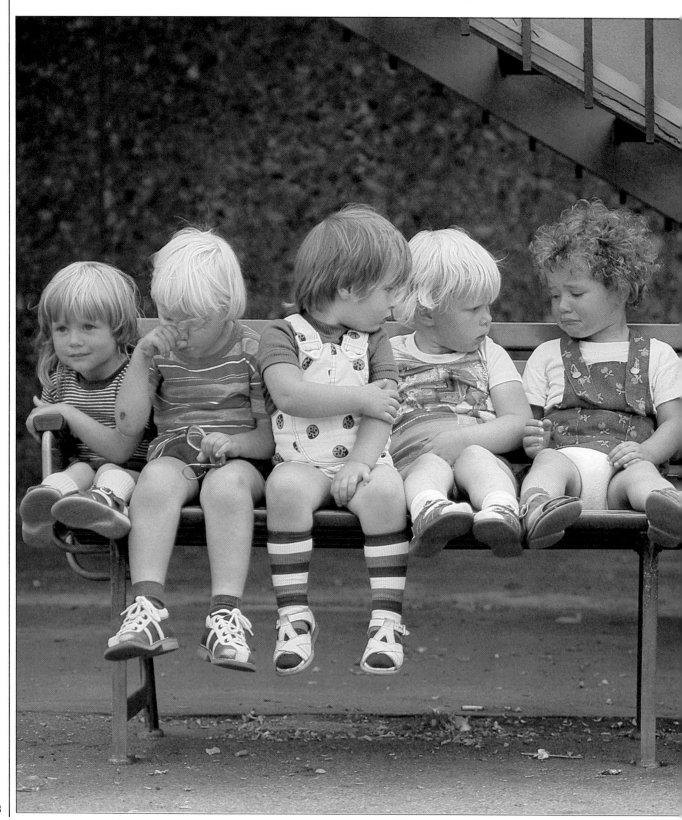

A lineup of tired children on a park bench makes a fascinating character study, packed with minor incident and varied expression. Some children are bored, others seem expectant – one group is engaged in settling a private dispute. The photographer prefocused, then dropped swiftly to one knee to capture the picture before the children noticed.

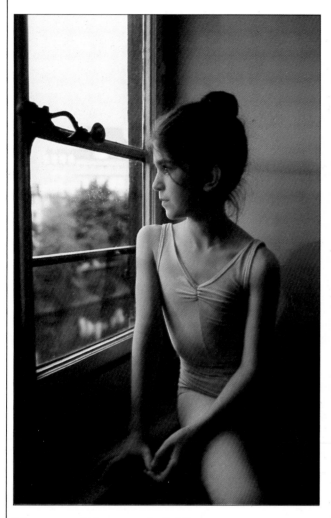

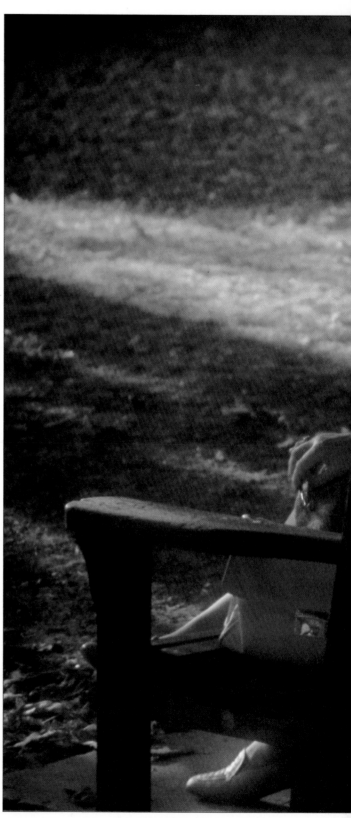

The unposed elegance of a fledgling ballerina is captured in this delightful informal picture, taken while the child was lost in thought. A moment later the expression might have changed. Soft light from the window is perfect for the delicate skin tones of her limbs.

The loving glance of a husband at his wife says everything about their amiable relationship. The couple's son took the picture from behind the bench while they were waiting for him to load the camera for a more posed photograph.

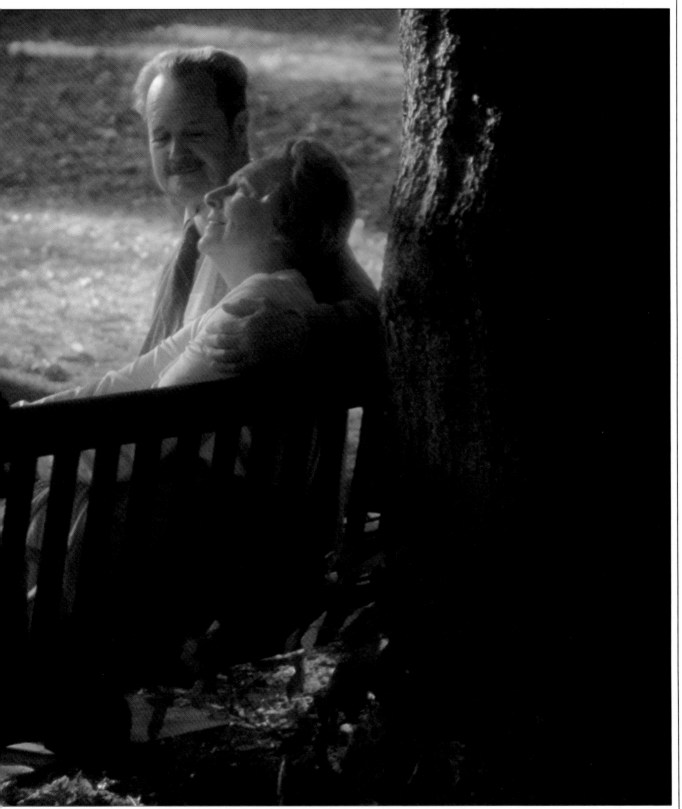

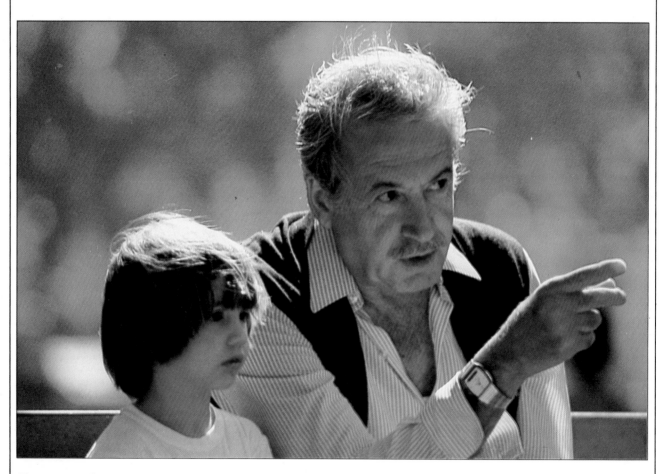

Two generations *separate the gray-haired grandfather from the child, yet for an instant a common interest united them. A photographer must act quickly to catch such charming moments of family life. Do not stop at taking just one shot – the third may be the best.*

An indistinct figure can be as true to our perceptions as a clear one. Here, the photographer glimpsed her son's reflection in a fogged-up window and saw an image that summed up her feelings about his leaving home.

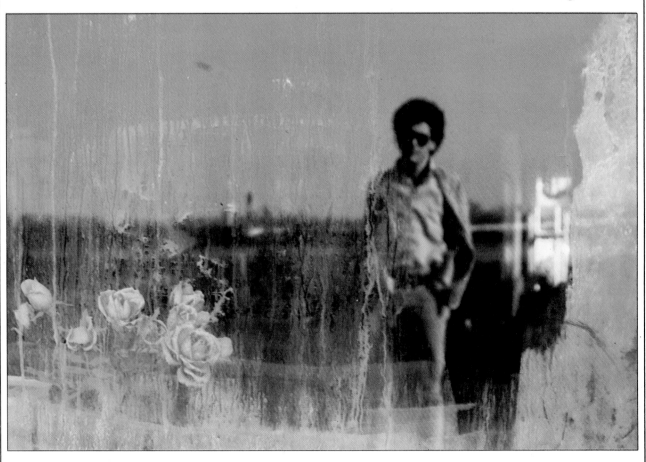

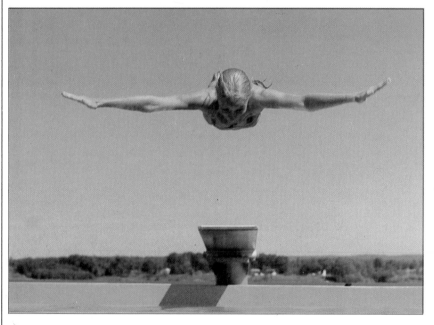

Suspended bird-like *above the swimming pool, a friend of the photographer's appears in a spectacular and memorable head-on view. The picture was one of several taken as the girl practiced the dive.*

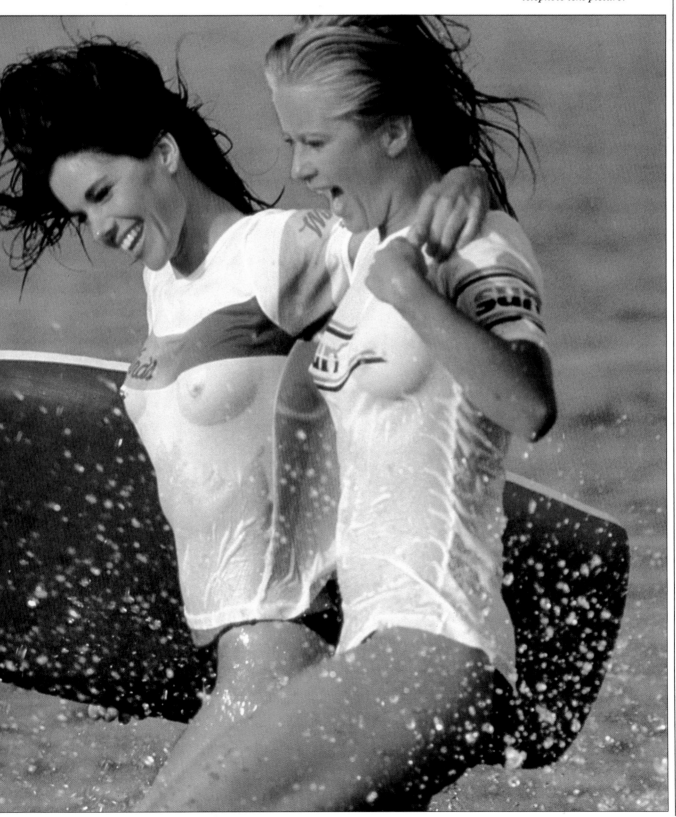

Two friends, a glitter of spray and the outline of a surfboard encapsulate the mood of a summer day in this tightly composed telephoto lens picture.

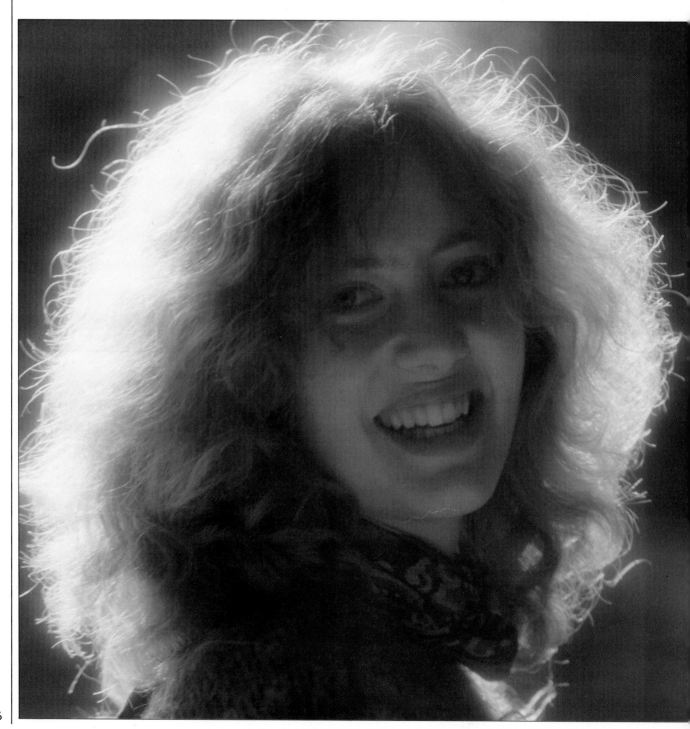

PEOPLE AT THEIR BEST

Everyone wants to look good in a picture. This is not to say that the photographer has to flatter people by trying to make them appear more attractive than they really are. However, it does mean that you should always do your subject justice.

Taking good pictures of people requires some forethought – it is surprisingly easy to end up with a muddled image, or one in which the subject looks bored, listless or wooden. What people really want is a picture that brings out their individuality and shows that they are alive. Whether you are taking the most informal snapshot or a carefully composed portrait to record a formal occasion, your aim should be to capture the essence of the subject's personality as reflected in a particular situation. Such clarity comes from knowing in advance what you want an image to portray, and then achieving your purpose in the simplest and most direct way.

The techniques explored on the following pages all show how to get the best from people – by reaching past the barriers that even friends and family put up before the camera, and past the clutter of surroundings, to arrive at the unique character of your subject.

The halo of light around a girl's tousled red-gold hair seems to embody the warmth of her laughter. By getting the subject to swing round suddenly, the photographer obtained a spontaneous and perfectly relaxed picture. Since the girl's face is out of the sun, there is no squint to mar the effect.

Expressing personality

Faces – especially the faces of people we know – are supremely eloquent guides to personality. Any photographer realizes the advantage of a vivid expression or gesture. Because of this, it is easy to forget that other elements in a picture also provide valuable clues to character.

Everything included in the final image can help in building an impression of the subject, from a person's hairstyle, dress and way of sitting or standing, to pieces of furniture and other objects – indeed the entire setting. Just by placing your subjects in a sympathetic environment, you can reveal something of their personalities. In the two close-ups below on the right, the colors of outdoor settings serve to reinforce the healthy appearance of the subjects. To take such spontaneous pictures, you need to decide in advance what aspect of your subject's character you want to emphasize, and then be on hand with a loaded camera until the moment you are waiting for presents itself.

Photographing people with their favorite possessions will speak volumes about their personalities. You do not need to clutter the picture with objects to get the message across: the best portraits are often those in which the photographer has singled out just a few telling details that seem to encapsulate a person's attitudes and lifestyle. Again, you should plan in advance what you want the picture to say about your subject. The carefully posed portrait on the opposite page is a classic example of how selected details can be strikingly used to express individual personality.

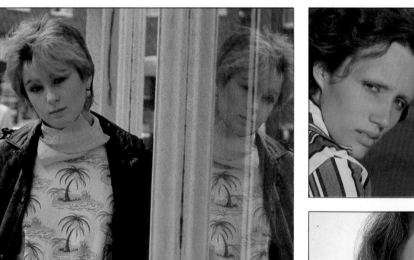

The tanned complexion and windswept hair of this girl, framed by a background of blue sky and water, convey simply but powerfully the independence and vitality of a fresh-air enthusiast.

A style-aware teenager props a shoulder against a boutique window. The girl's defiant attitude, the split image of her reflection, even the eye-catching motif on her shirt, combine to give an image full of character and vitality.

Radiating zest for life, this informal portrait taken at a ski resort acquires additional sparkle from the clean, bright background of the snow. The off-center position of the shot and the angle of the head help to suggest an easy-going, extraverted personality.

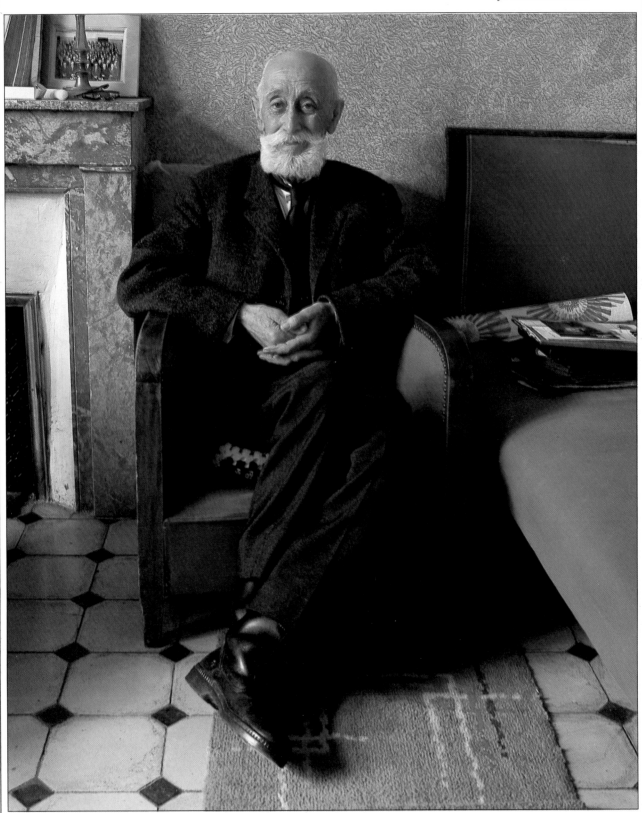

Relaxing the subject

Even your closest friends and immediate family – people who are normally quite at ease in your company – can freeze up suddenly when you aim a camera at them. The resulting picture may look stilted and unnatural.

Every photographer has to cope with camera shyness at some time. How you go about relaxing the subject depends partly on what type of person you are dealing with, partly on your relationship with him, and partly on the situation. To a certain extent, you will have to extemporize – but there are some advance preparations you can make. Get the technicalities out of the way well before the portrait session: decide which exposure, lighting angle and camera viewpoint you want – using a stand-in for the subject if necessary – and prefocus whenever this is possible. Unless you are confident of your technique, you are likely to seem nervous, and this will make your subject feel uncomfortable.

Think about props, too. One of the best ways of putting people at ease is to divert their attention from the camera. Giving your subject something to do will help, as in the pictures below of the boy playing with his father's pipe. Adolescents, particularly, tend to appear self-conscious and uncomfortable in portraits. Try to find a situation or setting that will give the subjects confidence.

If you are photographing a couple who enjoy a close relationship, such as the father and son shown here, you may find them becoming so absorbed in each other that they forget the camera completely. Such happy situations are more likely to develop if you remain as unobtrusive as possible. A long-focus lens allows you to distance yourself from your subjects, but still close in on any aspect of their image that catches your eye.

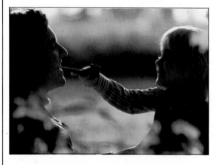
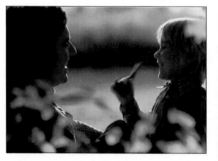

Engrossed in a game with a pipe, the father and son in the two pictures above are completely oblivious to the camera. The use of a 135mm telephoto lens has allowed the photographer to stay back and focus only on the smiling profiles, closely linked, and delicately rimmed by the sunlight.

With the boy relaxed (right), the photographer moved back farther to get a picture that showed more of the setting. The out-of-focus foliage adds to the soft, mellow mood of each of the photographs, and helps to create the sense that the father and son are occupying a private world.

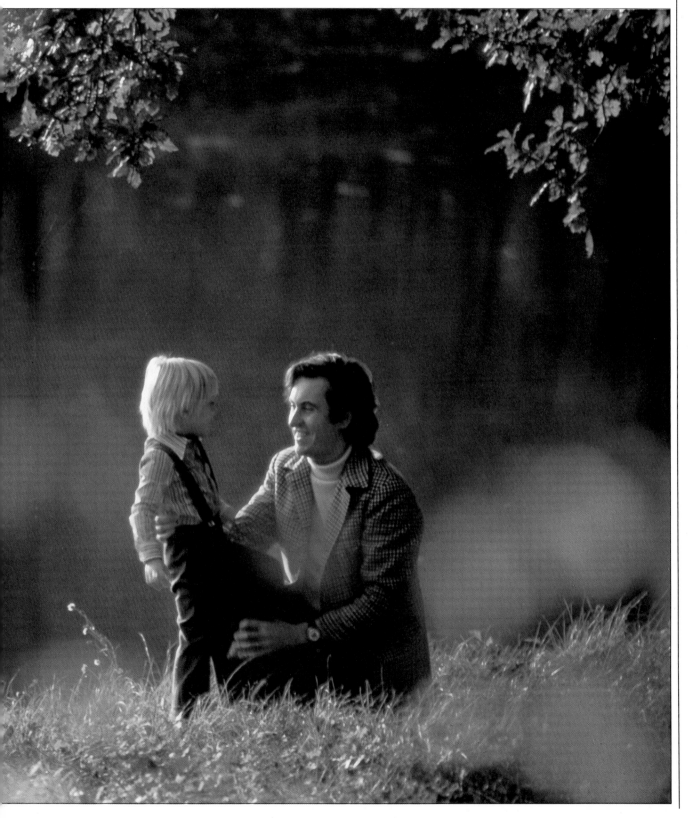

Composing the picture

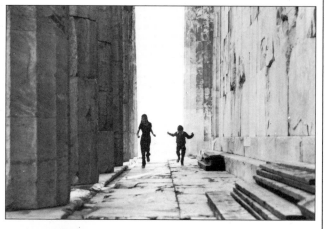

In trying to take a photograph that expresses the personality of a friend, or the spirit of a family occasion, you should not overlook the composition of the image. The balance of light and dark, the patterns formed by lines and shapes, and the effect of colors within the frame of the viewfinder can subtly influence the whole mood and atmosphere. For example, predominantly light tones can suggest an open, lighthearted personality, whereas a dark image may hint at somber introspection.

A single subject will provide the picture with an immediate strong center of interest – nothing draws our attention as swiftly as does a human figure. Having a focal point is almost always a compositional virtue. And you may be able to emphasize the subject further by using strong lines leading to the focal point – such as those in the picture on the opposite page at top left. But where in the frame is the best place for this main point of interest?

If you want your picture to appear harmonious, one way is to aim for symmetry. By placing the subject centrally in the frame, you can make the picture look more restful than by using a strongly asymmetrical composition. But you need to be careful to avoid dullness. In the picture of the boy at top right opposite, the photographer has sidestepped this cleverly by using a circle within a circle.

An alternative method of achieving a balanced effect without dullness is to make use of the classical principle of dividing the viewfinder frame into three equal parts. Try putting the most important feature – the main figure, or the eyes in a portrait – on an imaginary line bounding one of these thirds, vertically or horizontally. In the large picture opposite, the girl in jeans is standing two-thirds of the way across the frame, and the balance of the picture is perfect, in spite of the broad, blank areas formed by the theater screens among which she is posing.

The geometry of lines and shapes becomes still more important when you are dealing with more than one person. Rather than lining everyone up at an equal distance from the camera, try to vary the composition in depth or in height. And look for diagonal or triangular arrangements that help to link subjects together, suggesting their relationship as well as providing visual variety and movement around the picture area. The photograph at near right excellently demonstrates the way in which a feature – here the line of steps – can be used to strengthen a double portrait. Remember, too, the importance of scale in pictures of people – as in the photograph at top of children running through a temple. The figures are tiny compared with those in the picture immediately below it, but the eye is drawn to them because of their skillful positioning.

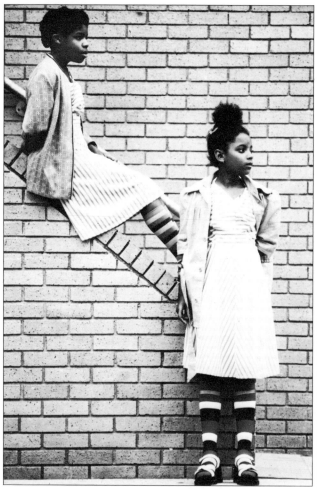

Twin sisters adopt different stances which suggest their individuality. To echo the strong rising direction of the pose, the photographer chose a vertical format.

Astride a windmill's axis, *this young tourist forms the center of a strikingly powerful composition – the sails of the windmill point like arrows to the human subject.*

A playground tunnel *frames a face in a circular composition. To complete the symmetry, the photographer asked the boy to cup his chin in his hands.*

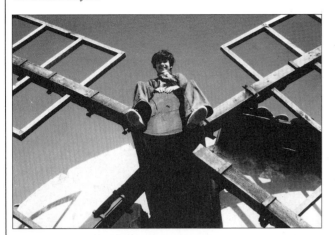

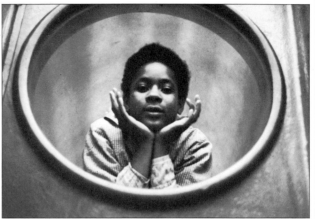

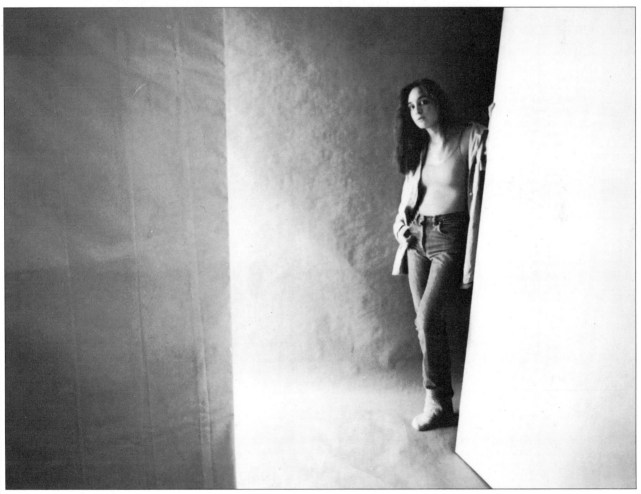

A casual portrait *gains elegance and formality from its classical proportions – the photographer used the stage screens to divide the picture into three sectors.*

Filling the frame

Filling the frame with just head and shoulders, or even with a single face, is a bold step to take. The effect is to concentrate all the viewer's attention on your subject's expression and features. And if these are not just right, there are no other points of interest on which to fall back.

But along with the risks go the potential rewards. Because a close viewpoint implies a more than casual bond between photographer and subject, a tightly cropped format is ideal for intimate pictures of those close to you. And by excluding all extraneous details from the image, the impact of the facial expression is increased. If the picture succeeds, the effect will be doubly arresting.

With a normal lens on your camera, you may need to move very close to your subjects in order to fill the frame with just their heads and shoulders. This can be intimidating, and can cause undesirable perspective distortions to appear – the nose looks too big, and the ears too small. A telephoto lens with a focal length of between 80 and 135mm is a better choice, allowing you to move farther back.

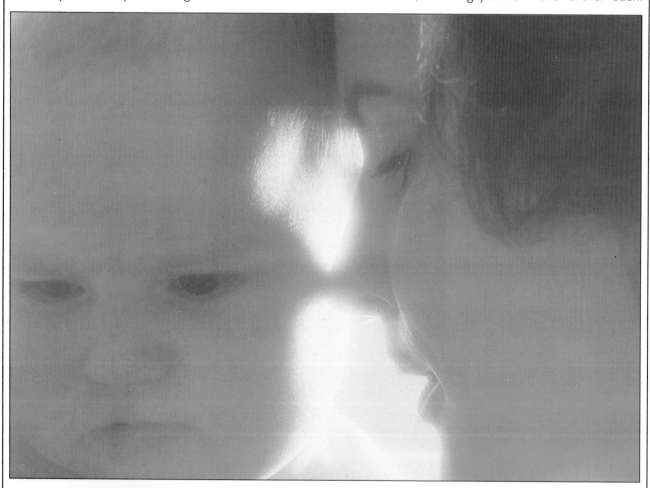

A mother and child have such a strong natural bond that they soon ignore the camera nearby. For these pictures of his wife and daughter, the photographer used an 80-200mm zoom lens, so that he could frame the picture in several different ways without having to move too close. Tight cropping gives interest to both of the photographs, but the one above – with the lens set at 200mm – better expresses the relationship.

You can achieve similar results, though with a slight loss of reproduction quality, by taking the picture with a normal lens, and including more of the subject, then enlarging the central portion of the frame at the printing stage. Both these methods give the subject more room, and produce a more pleasing perspective on film.

Whichever approach you take, you should use a small aperture, to keep as much as possible of the subject's face in focus. At close distances, depth of field becomes very shallow, and accurate focusing is essential, or the fine detail such as hair will begin to look blurred. Focusing on the eyes helps to avoid this – if they look clearly defined, slight lack of sharp focus elsewhere in the picture is acceptable.

Lighting is important, too. A pin-sharp portrait invites detailed scrutiny of the subject's face, so even small lines can seem obtrusive. For this reason, soft, diffuse light – such as the light from a large window or light reflected from white paper – is more flattering than the glare of direct sun, which tends to reveal every wrinkle.

A beach close–up captures the brisk freshness of a dip in the ocean. Faced with the problem of a crowded scene and an unsightly seafront ahead of him, the photographer opted for a tightly cropped picture, which concealed most of the background detail yet retained a little of the sky and beach. A white parasol, planted in the sand alongside, diffused the light from the sun just enough to soften the shadows a little.

The perfect compromise

Although a tightly cropped portrait can be both dramatic and intimate, there are times when a broader view conveys more – a person's stance, or the way he holds his arms, often provides a valuable insight into his character. On the other hand, a full-length portrait can seem impersonal, because of the distance between subject and viewer, and because the face, which is the most expressive part of the body, forms only a small part of the image.

A half-length picture, cropped at the waist or below, can be the perfect compromise. It includes a little of the subject's clothes and surroundings, but still shows subtleties of facial expression. This sort of portrait works particularly well when the subject's hands and arms are constructively occupied or when you are taking a double portrait for which a horizontal format is more suitable, as below.

With a normal 50mm or 55mm lens, half-length pictures are easier to take than images cropped at the shoulders or neck. Because you can stand farther away from your subject, the depth of field – always limited at close range – is greater, and focusing is correspondingly less critical. Moving back also makes the subject feel more comfortable, and eliminates the unnatural perspective that can spoil close-up portraits, especially by making the nose seem too large in proportion to the rest of the face.

In composing such a picture, pay special attention to where the edges of the frame cross the figure. If you include too much – perhaps by cropping just above the ankles – the crop may appear to be an error. When cropping is tighter, however, you run the risk of lopping off hands – the most important element in a portrait other than the face itself. Be prepared to move back or forward to adjust the view. The best crops are likely to be at the waist, the hips, or above the knees. If you are in doubt about the best framing, always include too much – because the excess can be trimmed off the print, or masked off the slide. Once you press the shutter, however, a picture that has been too tightly cropped can never be remedied in this way.

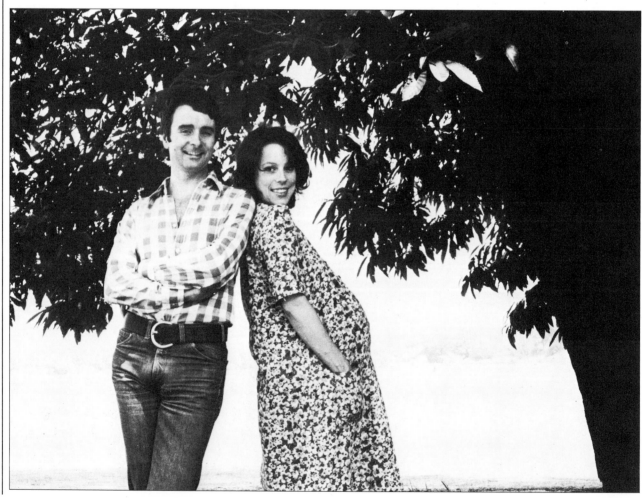

A grinning farmer, posing for a friend, occupies only the lower half of the picture frame. In order to emphasize his subject's muscular forearms, the photographer tilted the camera upward, allowing the featureless wall to fill much of the picture area. The result of this apparently eccentric composition is a portrait of unusual character.

Cropping the picture can convey a sense of dynamism even in an image that is relatively static, as in this scene. The children have paused in the middle of a game, but the picture still conveys a strong sense of movement and activity.

Mutual support (left) in a relaxed portrait of a young married couple is conveyed by the angle of their bodies. The horizontal format crops them but brings into the frame the lean of the tree and its protective canopy.

The right lens

Catching a telling expression or pose is the key to many successful pictures of people. But choice of lens may play an important part in determining the composition and impact of the picture. A normal 50mm or 55mm lens – excellent for half- or full-length portraits – has the outstanding merit of showing people in a natural scale with one another and with their surroundings. Yet you can expand your creative range when photographing people by trying lenses with longer or shorter focal lengths, especially for certain subjects.

A telephoto lens has two distinct qualities that make it useful. First, its magnifying effect allows you to stay well back so that you can fill the frame with a head-and-shoulders portrait without crowding the subject. And second, the shallow depth of field of this lens becomes a particular asset in portraiture, when often you want to blur a confusing background so as to provide a plain frame for the main subject. A lens with a focal length of 200mm or larger can be used, but those of 80mm to 135mm are usually adequate – and certainly easier to handle.

Wide-angle lenses come into their own when, conversely, you want to include background or foreground details in the picture – either because the setting is interesting or because it supplies a kind of commentary on the character or interests of the subject. Moderately wide-angle lenses are the most useful, particularly those with focal lengths of 28mm or 35mm. Their broad angles of view and great depth of field mean that you can show sharp details of a subject's environment, whether these details are close to the lens or distant.

A wide-angle lens has special advantages when you are photographing large groups. You can fit everybody into the frame without going so far back that the faces and expressions become lost. Sometimes, too, the tendency of wide-angle lenses to distort perspective at close range can be used creatively, as in the picture of the boy on the right, who is challenging all comers to invade his private territory in a tree house.

An old man's head looks as grand and imposing as a biblical prophet's, an effect helped by the close framing and shallow depth of field of a 200mm telephoto lens. The distance from which you can get close-ups with this lens allows the subject to remain relaxed.

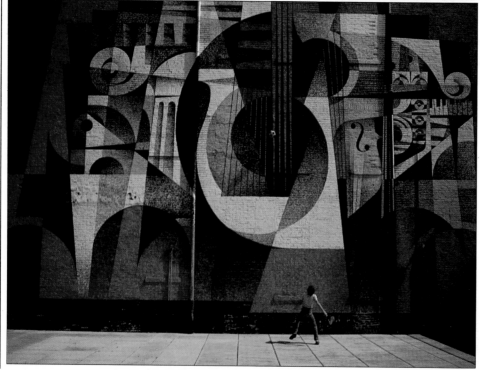

A huge mural dominates the boy's solitary ball game in this unusual picture, taken with a normal lens. The sense of scale would have been less impressive with another focal length: a wide-angle lens would have made the wall appear smaller, and a telephoto lens would have included only part of the scene.

Ways of looking

People's eyes are their most recognizable features. They have a magnetism that both compels our attention and draws us into the depths of the personality behind the face. As a result, nothing has more influence than the eyes on the particular mood and meaning of a portrait.

Each of the four pictures here tells a different story, and in each the eyes convey the essential message. A direct gaze can have different meanings, depending on the relationship between the photographer and the subject. Generally, a friend or relative who looks straight at the camera is expressing a friendly and relaxed openness. But the same gaze from a stranger in the street might convey challenge or even hostility. In either case, there is a strong sense of involvement, and we are conscious that the subject is aware of the camera.

However, a good portrait by no means depends on a level, eyeball-to-eyeball confrontation with the camera. A picture of someone looking away from the lens may succeed because the element of awareness seems missing. The resulting effect may be more spontaneous – a glimpse of someone lost in private thoughts, or reacting, like the woman at bottom right, to something happening outside the picture frame. The look away needs to be positive; asking the subject to glance slightly past the lens can produce an unfortunate impression of shiftiness. On the other hand, a pose looking toward the camera with the head turned slightly away can strike an effective balance between a formal and informal portrait. And a bright-eyed glance over the shoulder, as in the picture at far right, can imply impishness, innocence or both at once.

On a more technical level, there are two fundamental reasons why you should watch the eyes closely when you take a picture of someone. First, they move more rapidly than any other part of the face. Second, if the eyes appear to be in sharp focus, so will the rest of the face.

The direct, troubled gaze of a girl on the verge of adolescence gives this portrait an introspective intensity that is almost disconcerting. A telephoto close-up and a strict composition heighten the impact.

Gripping her mother's hand for reassurance, this youngster conveys both vulnerability and surprise. The camera position – looking down from above – makes her seem even smaller, and the message in her eyes more poignant.

A mischievous grin spreads across the face of a seven-year-old, as if caught in some minor prank. Using a 135 mm telephoto lens, the photographer set the focus on the back of the boy's head, then asked him to look around quickly.

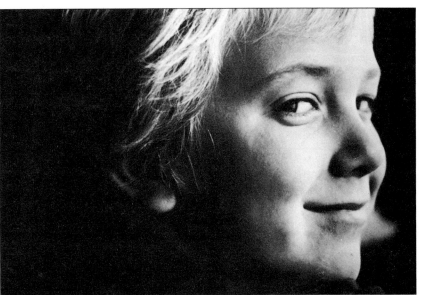

A sideways glance carries the attention across the full width of the picture frame, as if the woman is sharing a joke with someone standing opposite. The effect is lively and convincingly spontaneous.

At work and play

We define people as much by what they do as by the way they look, and friends or relatives engaged in activities, whether at work or play, make excellent subjects for informal photographs. Such pictures can reveal fresh facets of personality in someone we know well – and they often succeed in bringing a person to life when a more orthodox and straightforward portrait would fail to do so.

This is true particularly if your subject tends to be ill at ease before a camera, or has a reserved personality that is difficult to draw out in a posed picture. The great advantage of photographing people intent on what they are doing is that they are unselfconscious. In addition, shared absorption in a hobby, task or game makes it easier to capture a relationship between people. The pictures here of friends tussling over a basketball, of a young fisherman with his grandfather, and of a camera-shy farmer shearing a sheep, are all examples of people who are completely in their element, and therefore at their most natural and authentic.

Remember that the activity itself will provide more than enough visual interest – so keep the background simple and concentrate on a few selected details. Pictures of children playing are particularly difficult to organize coherently, and you may find that a high viewpoint helps to separate the figures, as in the picture below.

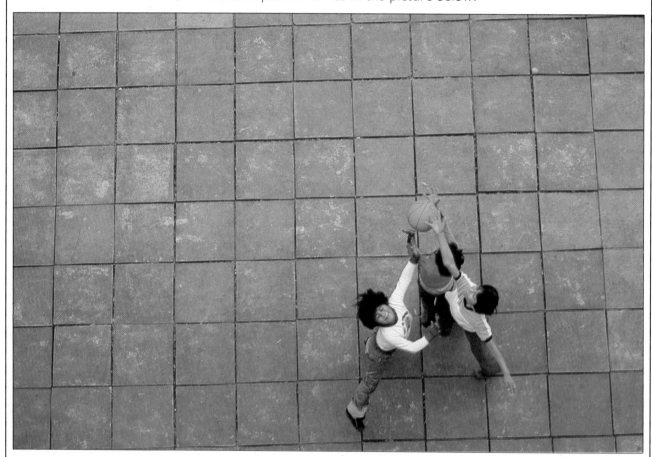

An overhead view of three friends playing basketball has brought clarity to what might have been a confusing picture. The triangular shape of the figures with the colored ball at the apex, is well placed in the frame, and emphasized by the plain, square tiles. Yet the outstretched fingers and straining expressions of the boys still capture the feeling of movement.

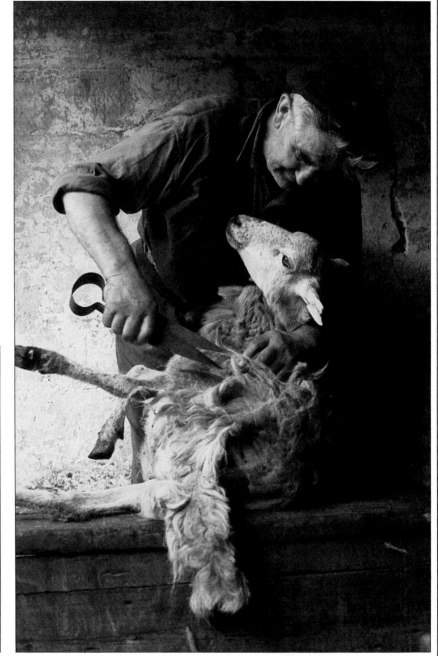

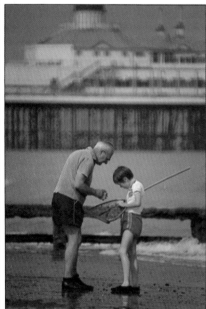

The art of shrimp netting *absorbs a boy and his grandfather at the seaside. The intent concentration of the pair excludes the camera's presence – an effect the photographer helped by the use of a telephoto lens. A shallow depth of field has kept the subjects and the reflections in the wet sand sharp while blurring the breakwater and the pier in the background of the picture.*

A shaft of light *focuses attention on the balanced shapes of two faces, one bent down over his task, the other tilting upward. The photographer respected the shearer's reluctance to have a formal portrait taken, and by waiting quietly, captured this telling picture of strength, experience and care. The simple stone wall contrasts well with the sheep's woolly coat.*

Capturing smiles

The image of a spontaneous smile enchants us because every time we look at it we can taste something of the subject's joy. A thousand different circumstances may produce the moment no photographer wants to miss — when a face lights up with pleasure, radiates mischievous glee, or breaks into helpless laughter. The occasion can be as inconsequential as a children's game, or as special as an anniversary reunion. Whatever the cause, the effect is unmistakable — a sparkle that brings the picture alive, almost regardless of its technical merit. Catching someone's laughter on film is almost like putting bubbles in a bottle.

Anyone who has tried to make a subject smile for the camera knows that genuine laughter can seldom be prearranged. The best way to spark off the moment of gaiety yourself is to use an element of surprise. Then everything will depend on your own speed of reaction — which means that you must set the focus and exposure in advance.

The same is true if you rely on the situation to produce the mood. A celebration, a reunion, a funny story, the exhilaration of movement can all be anticipated and all are likely to result in laughter. If you are well prepared and well positioned, alertness and luck will do the rest.

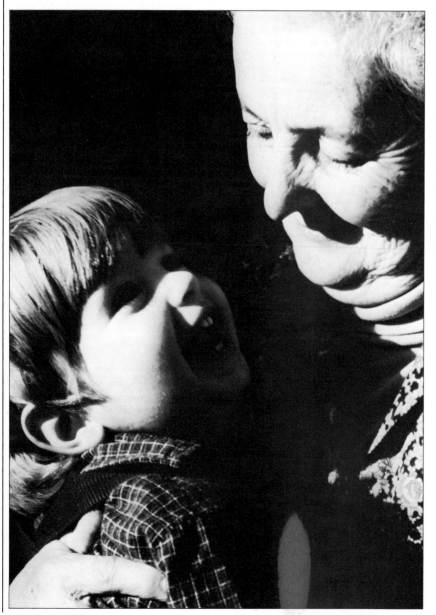

The responsive smile of a young girl, surprised during a sunbathing session on the beach, reflects her fun-loving nature. The photographer caught the girl's attention by making an amusing remark, so that she turned her head with the smile already on her face – to be snapped swiftly before the expression had time to fade. Although the moment was contrived, a fast reaction with the camera makes it seem spontaneous.

Undisguised pleasure in a mutual affection shines out of this portrait of a little boy and his grandmother (left). Observing the tremendous bond between the couple, the photographer framed the composition tightly in order to emphasize their closeness. Slight overexposure allows the strong light falling on the woman's face to blank out some wrinkles, and brings out detail in the shadowed face of her grandson.

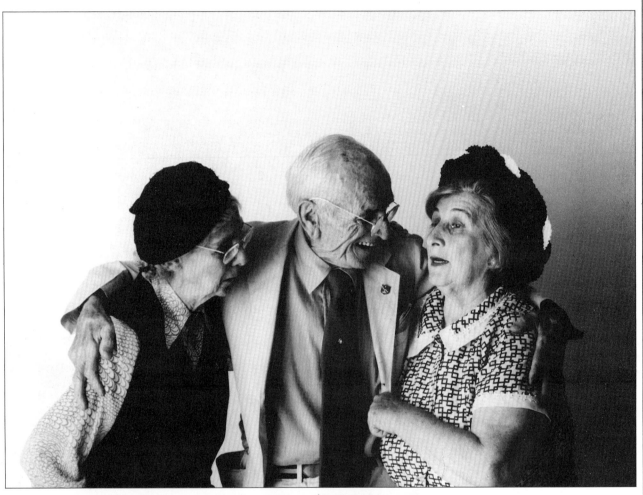

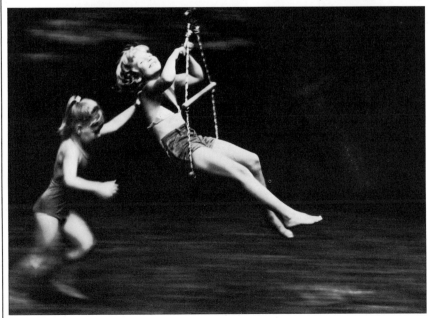

Laughter's powers of rejuvenation are demonstrated in this photograph of an elderly trio of friends at a reunion party (above). At crowded functions, such pictures require patience. If possible, wait until your subjects form a coherent group and are immersed in conversation. And try to find a plain background. Here, the white background gives freshness and clarity to the image, accentuating the shapes of the figures.

A child on a swing glows with delight. By using a slow shutter speed and panning the camera to follow the swing, the photographer got a sharp image of his elder daughter while blurring her small sister and reducing the background to streaks of tone. As a result, the swinging girl seems to be suspended in mid-air, and her uplifted face and arms give the impression that she soars with joy.

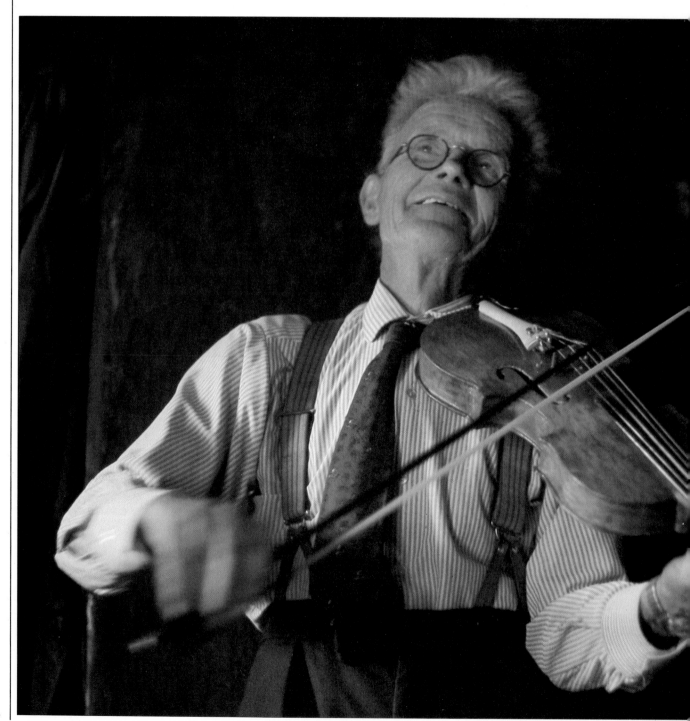

MATCHING LIGHT TO SUBJECT

The myriad subtle differences between one person and another – in coloring and features, expressions and moods – mean that choosing the right lighting for a human subject is of crucial importance. Photographs of people that are perfect in all other technical respects will be disappointing if the light is unsympathetic.

What is ideal for one sitter may obscure the good points or bring out the worst features in another. For example, backlighting may dramatize an interesting profile; or it may blot out the telling lines in a face seamed with experience. Equally, strong sidelight may throw those same expressive wrinkles and hollows into emphatic relief, but show nothing of the peaches-and-cream softness of a young complexion. Soft light – naturally diffused, reflected or filtered – will flatter most subjects. Yet sometimes, bright directional light that illuminates only parts of a figure – as in the photograph on the left – is exactly right.

The section that follows explains how you can make the most of available light; how, by manipulating the camera's controls, you can use light to enhance mood or character; and how you can modify it artificially to obtain particular contrasts. Above all, placing your subject in the best light depends on knowing how to adapt your approach to the individual you are photographing.

The rapt expression and agile hands of a violinist are accentuated by strong oblique lighting. A low angle ensures that the fingers on the strings and the instrument itself dominate the picture, while the mahogany tones of violin and weatherbeaten face have a harmonizing effect.

Sunlight or cloud?

Bright sun and blue sky may seem ideal conditions for photography, but they are seldom good for photographing people. Strong sunlight is too intense to show subtleties of skin tones and texture, and from some angles the harsh light can turn fine lines of character into deep wrinkles. The high sun of noon has particularly unattractive effects, putting deep shadows under a subject's nose and chin and making the eyes sink into dark hollows. In these conditions, look for an area of open shade with enough soft, reflected illumination to light your subject adequately.

The weaker sunlight of morning and evening is much better. Even so, people will find difficulty in facing the sun with their eyes relaxed and open, and you should try to place them so that the light falls on their faces at an angle of about 45°. The soft reddish light of evening warming a tanned face and glinting in the subject's eyes can convey the glow of a summer's day more effectively than the harsh light of noonday, as the amusing and inventive group photograph below shows.

If you want to use oblique directional daylight to bring out the strength of a face, thin clouds or haze will help to diffuse the sunlight and reveal some form. Thicker clouds go farther in diffusing the light, and provide gentle modeling of a face, as is evident in the picture of the old lady opposite with a sheaf of wheat. In addition, overcast weather eases the technical problem of choosing an exposure to suit both highlight and shadow areas without losing detail in either. The ideal illumination is the broad, even light of an overcast day, which is muted but not dull – this kind of light reveals detail clearly but does not create the hard shadows that can ruin a picture. Less-intense light also enables you to open up the aperture so as to reduce depth of field if you need to blur out a background.

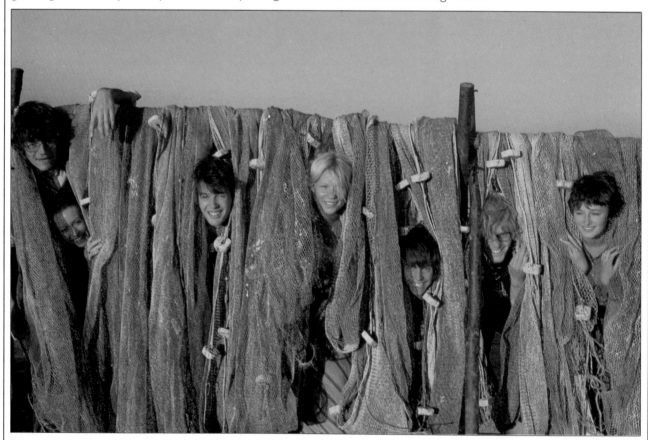

Fishing nets on the beach frame an unusual group portrait in which the low evening sun tinges the faces with warm orange light. Harsher noon sunlight would have shown less texture in the nets, and cast obscuring shadows.

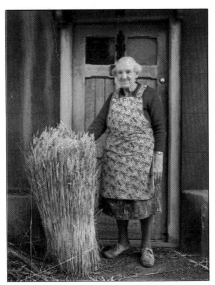

Harvest home, and proud of her ability to help, this elderly farmer's wife stands in light diffused by heavy clouds, so that only soft shadows play over her lined face. The fine detail shows what effective pictures can be taken in this light. To offset the blue color tinge that overcast weather often produces on slide film, the photographer used a No. 81A pale yellow conversion filter.

A lazy day by the sea comes to an end for a beach sitter as hazy clouds reduce the intensity of the afternoon sun. The pale, even light and muted colors helped the photographer to capture a picture that evokes the atmosphere perfectly.

Backlight and silhouettes

Backlighting, with the light coming from behind the subject, changes our view of a person dramatically by emphasizing the outlines, rather than the detailed forms, of faces and figures. Because people can be identified by outlines alone, when you know them well the results of backlighting can be distinctive and intriguing – a combination of familiarity and mystery.

Depending on the strength and source of light, and the exposure, you can create very different effects with backlighting. Intense light produces dark, almost two-dimensional silhouettes, like those of the children in the photograph below, if you take the meter reading for the bright background. When there is also some frontal lighting – either direct or reflected – you can retain some of the details in silhouetted shapes. For example, in the picture on the opposite page, the photographer chose an exposure that allowed strong sunlight reflected through the window to reveal the delicate tone of the girls' skin. If the sun is not directly behind the subject, the result may be a silhouette ringed with light. Rim lighting, as it is known, imparts a radiant warmth, particularly suited to romantic portraits such as the one on the right.

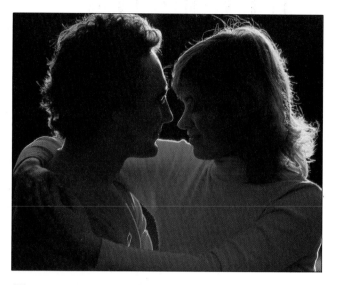

The aura of light around an embracing couple adds to the romantic intensity of this close-up photograph, while the silhouetting of the figures conveys the impression of a private moment.

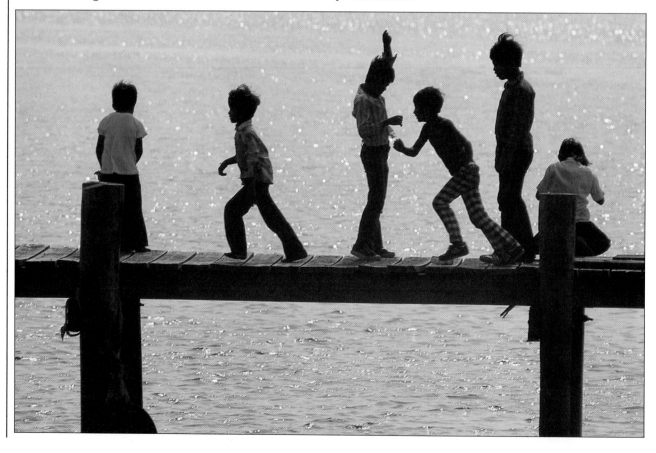

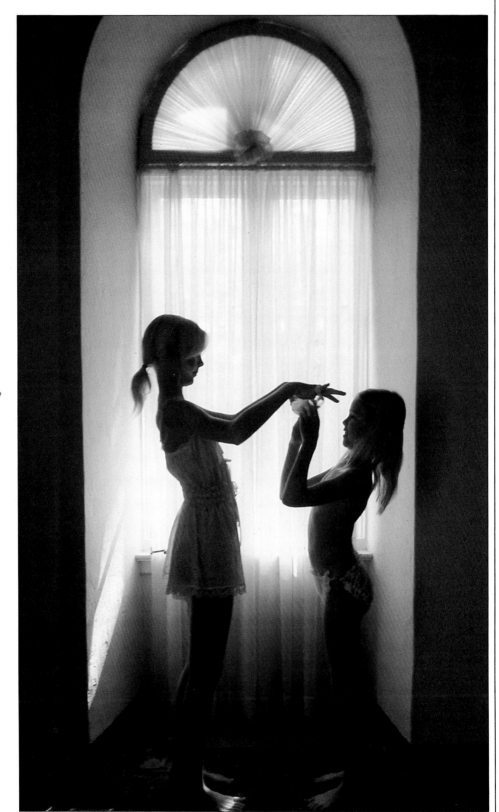

Children playing on a jetty (left) are transformed into almost hieroglyphic figures by strong backlighting. The photographer set an exposure for the lighter background, underexposing the figures to obtain the black silhouettes and monochromatic setting.

The willowy profiles of two sisters are backlit by sunlight delicately filtering through curtains. Reflected light from the window gently dapples the girls' soft skin and picks out details in the silhouettes, while the shape of the alcove accentuates the subjects' long, slender limbs.

Modifying the light

For photographing people indoors, no source of lighting is as natural and convenient as the daylight coming through a window or an open door. Usually the light is reasonably bright, with none of the color-balance problems of household lighting.

However, unless the room has large windows on more than one wall, window light tends to be strongly directional. If you do not take steps to modify the light, half of your subject's face may come out bright and the other half in deep shadow. Occasionally, this can be an advantage. For the picture below, the photographer deliberately restricted the light from a sunlit window to a narrow beam. As a result, the contrast of light and shade draws attention to the strong lines of her friend's face and chin.

More often, you will want to avoid stark differences between highlight and shadow areas. Strong contrast makes it difficult to select the best exposure for showing natural skin tones or for revealing the subtleties of facial form. One way of reducing contrast is to reflect some of the light streaming through the window back toward the shaded side of your subject's face. For example, the book the child is reading in the picture at the top of this page not only makes a natural prop but also serves the very practical function of lightening shadows on her face. Alternatively, you may be able to place your subject closer to a light-colored internal wall that will reflect back some light.

Softening the light from the window can also help to mute the brighter part of a scene, so that you can increase the exposure and show more detail in the shadows. Lace curtains or translucent blinds will help to diffuse the daylight entering the room. An equally effective diffusion technique is to pin a bed-sheet or tracing paper across the window frame.

A young reader sits by a window, and bright sunlight flooding into the room gives her hair a halo of light. Unmodified, the strong back-lighting would have thrown her face into deep shadow. However, the photographer used her book to bounce back some sunlight and soften the harsh contrast.

Peering from shadows, the young woman at left leans into a pool of light. The photographer needed some way of excluding from this picture the over-cluttered surroundings of the room. She pulled heavy curtains and moved in close for a strong picture that uses just a chink of light.

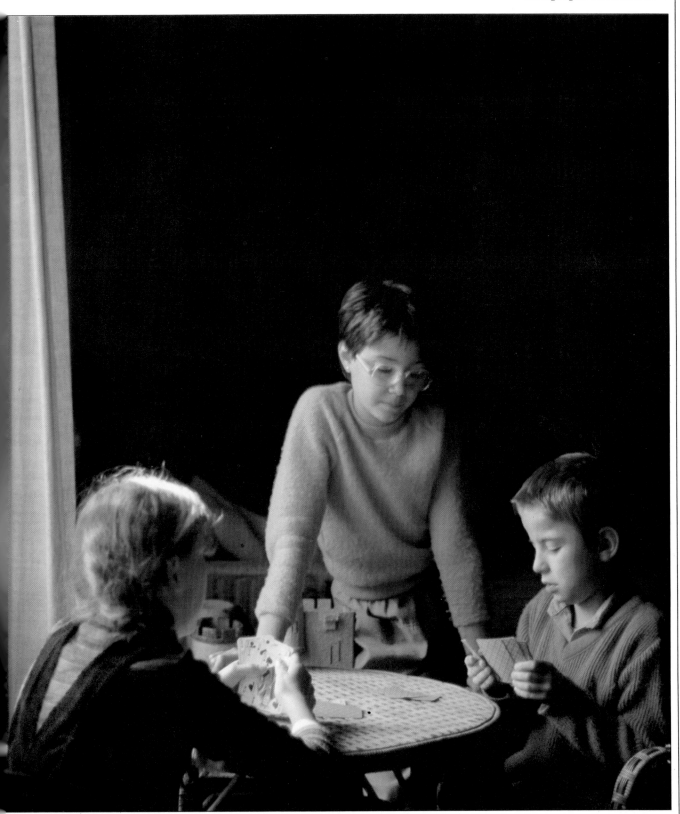

Using portable flash/1

Small flash units are a convenient additional source of light, especially when you are taking pictures of people in the low levels of light found indoors. They are powerful in spite of their small size, and most modern units are automatic: they have a sensor that controls the duration of the flash while the camera's shutter is open, terminating the flash when sufficient light has reached the subject for correct exposure. Such efficiency tempts some photographers to use a flash unit mounted on top of the camera for all their indoor photography. But you cannot expect the pictures taken this way to be consistently pleasing.

The problems derive mainly from the harsh quality of direct electronic flash, which has particularly noticeable effects in pictures of people's faces. An ordinary flash unit is such a small, intense light source that it casts strong, clearly defined shadows. With the flash mounted on the camera and the camera aimed squarely at a person's face, the shadow will appear as a hard, dark line around the features, and the light will create an unnaturally flat appearance, certainly unappealing, and perhaps even ugly. In addition, an effect known as red eye can make a person's pupils look like blood-red circles – like something out of a horror movie – because light shining directly into the eye reflects back from blood vessels in the retina.

A further problem is caused by a reduction in the intensity of light, known as fall-off. Light disperses in all directions as it travels, and thus quickly loses intensity. The effect is minimal if the source is a very broad, powerful one, such as the sun. But the light from a small flash unit aimed horizontally at the subject will illuminate nearby people very brightly, while those farthest away will merge into shadows. This effect is especially difficult to avoid with the flash mounted on top of the camera; for the people in the picture to be equally well exposed, they all have to be the same distance from the camera.

You can use several simple techniques to overcome these potential problems. Many flash units have a head that you can direct upward to bounce the light off a ceiling. The light thus spreads out from a broader reflective surface, giving more even illumination. Other reflective surfaces can be used to bounce light if the flash head swivels in all directions. Bounce flash prevents red eye and also casts softer shadows, which help to define forms. Another way to reduce red eye is to have your subject look at a bright light just before you take the picture: as the pupils contract, red eye becomes less noticeable. When you cannot bounce the light, you can still improve your pictures by moving the flash unit a short distance away from the camera so that the shadows fall more obliquely. Mount the flash on a special bracket that fixes to the camera base, or use a synchronization cable and hold the unit to one side or above your head as you take the picture.

Overcoming red eye
1–With a flash unit mounted on top of the camera the light reflected back from the retinas of the man's eyes makes his pupils appear red and unattractive.

2–Moving the flash just a little, by holding it above the camera, removed the red eye effect. This technique also casts slightly longer shadows, giving more form to the features.

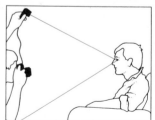

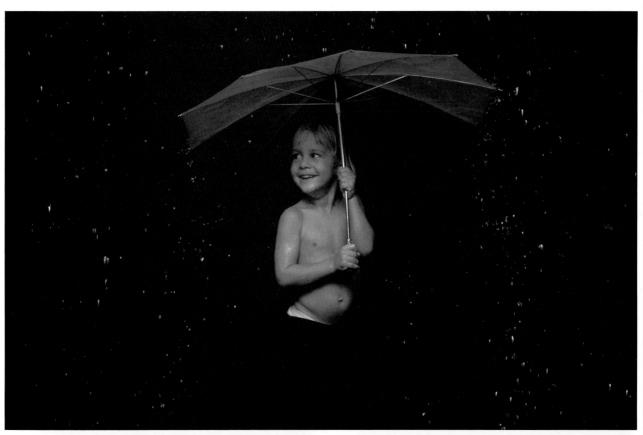

A shower of rain sparkles around a boy lit softly and evenly by bounce flash. The photographer redirected the flash off a white porch just in front of the child.

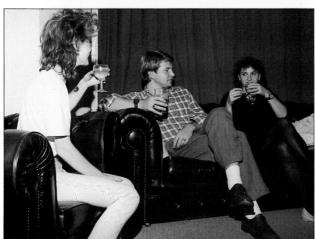

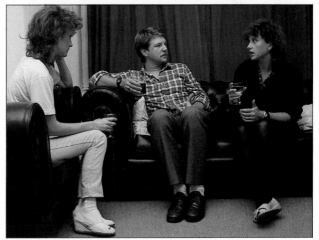

Overcoming fall-off
1–With a direct flash, the girl nearest the camera received too much light, while the one farthest back received too little. Overall, the light appears harsh.

2–By moving camera and flash, with his friends at a more equal distance, and bouncing the flash off the ceiling, the photographer achieved much more even and natural lighting.

Using portable flash/2

Many photographers tend to use a flash only when darkness has fallen, or when the available light is unacceptable for picture-taking indoors. But in fact, a portable flash unit can be extremely useful even in broad daylight. By using a flash as a supplement to natural light, you can enhance open-air pictures of people in subtle or dramatic ways.

On dull days, flash can brighten up parts of the scene near the camera, as in the fine picture of a family at the bottom of the opposite page. Daylight has provided the main light, for both the surroundings and the group in the foreground, but a flash has given a distinct yet unobtrusive lift to the colors and highlights. In strong sunlight, the same lightening effect can help to balance a picture by softening the shadows. For example, a carefully directed flash can throw extra light on one side of a person's face.

The important thing to remember when you are using a flash as supplementary lighting is that the daylight – your main source – should dominate.

Unless the light is bounced, a flash aimed at a nearby subject at full power will give an unnatural result. To avoid this, set the exposure for daylight and reduce the power of the flash.

Some sophisticated flash units have a control that will enable you to reduce the output to half. With other automatic types, you will have to increase the film speed on the unit to twice the ISO rating of the film you are using. With manual units, tie a white handkerchief over the flash – double thickness.

None of these methods needs to be applied too exactly – just be sure to reduce the flash power considerably. In addition, you can use a flash outdoors to create special effects, especially with moving subjects. The extremely short duration of a flash will freeze very fast movement. To achieve this, set the exposure so that the flash operates at full power. The background will appear unnaturally dark, but this in itself can add to the effect – as in the picture of a girl by a waterfall, below right.

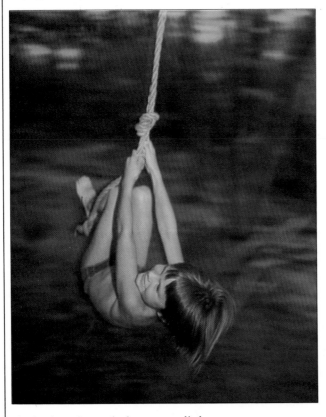

Swinging through the trees, a little girl is frozen by the burst of light from a portable flash unit. Panning blurs the background, lit for the full exposure time of 1/90 by daylight, and a ghostly shadow in the girl's wake shows where her moving body blocked the light.

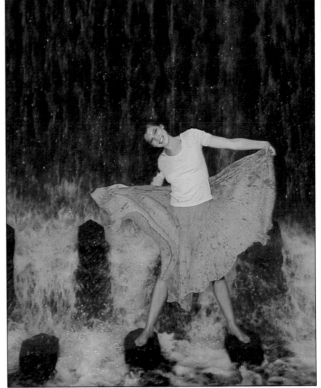

Standing by a waterfall, a girl appears unnaturally bright. To achieve this dramatic effect, the photographer set the exposure for the flash and ignored the weaker sunlight illuminating the background. Farther away from the flash, the waterfall is underexposed and dark.

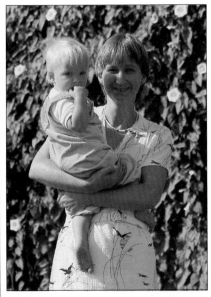
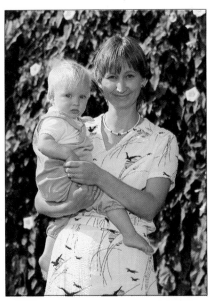

Two garden portraits (*left*) *show the advantage of a portable flash when the sun is strong. In both pictures, sunshine is the dominant light source, but for the nearer picture, the photographer added directional light from a small flash unit. Careful adjustment of the unit's output enabled him to brighten up the shadows with a controlled burst of light from the right of the camera and put a sparkle into his subject's eyes*

The family group seems at first sight to be lit only by natural daylight. In fact, the photographer took the picture on a dull day in early spring, but added color and life with the subtle use of a flash — at reduced power and bounced back toward the subject from a large white card positioned above the camera.

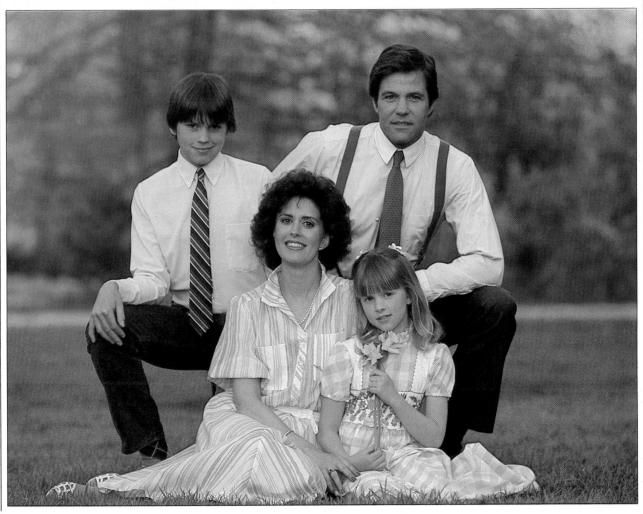

The soft-focus portrait

Soft focus in a picture imparts an ethereal, half-seen quality – an air of misty romance. Unlike an image that is completely out of focus, the soft-focus image has an essential clarity, but with slight diffusion of the fine detail, almost as if you were looking through steamed-up spectacles. In fact, as the right-hand picture of the couple below shows, you can create the effect simply by breathing on an ordinary lens. Other ways of improvising soft-focus images include placing cellophane, gauze, or even a nylon stocking, over the front of the lens. Or try smearing a clear ultraviolet filter with grease or petroleum jelly, in patterns to suit the effect you want.

Greater control is possible by using one of several manufactured accessories. The best device – but also the most expensive – is a special soft-focus lens, sometimes called a portrait lens. By permitting control of its designed aberrations, this type of lens enables you to vary the degree of softness. However, you can use special filters to achieve somewhat similar results at far less expense. These filters have a pattern of concentric rings engraved on them, or have an overall translucence. With through-the-lens metering you take the picture in the normal way. Otherwise, allowing an extra half-stop exposure will compensate for the light that is absorbed by the filter.

In photographing people, the softened edges and reduced detail of soft focus can flatter the subject, hiding wrinkles or adding a glow to highlights on cheeks, hair or in the eyes. Light coming from behind the subject will seem to flow out and around the silhouetted person. The results can be very attractive. But be careful – with overuse, soft focus becomes a tired visual cliché. Look for more imaginative approaches, such as that on the opposite page, where the photographer took the picture through a sheet of frosted glass. The glass breaks up the shapes and colors intriguingly, only half-revealing what lies on the other side.

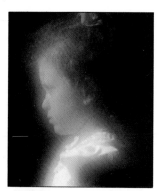

A child's face and dress glow with a diffused halo of light, an effect produced by a soft-focus filter that has spread out the light reflected from bright parts of the subject.

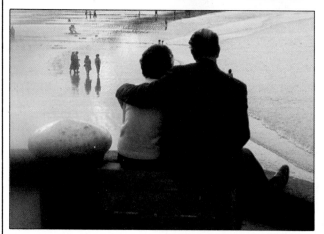

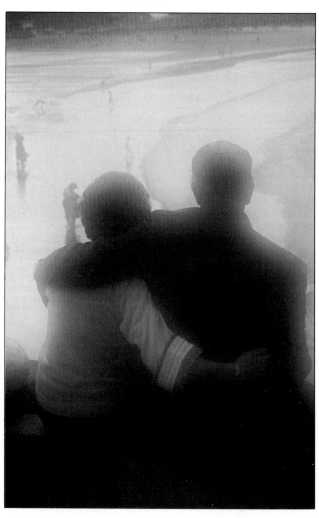

A couple gaze out over the shore (above). By breathing gently on the lens just before taking the picture at right, the photographer evoked a softer, more misty, mood.

Through frosted glass, a girl's figure becomes almost an abstract pattern of soft, colored shapes. With the subject on the far side of a window, the photographer focused on the glass itself, accentuating its texture and allowing the subject to remain blurred.

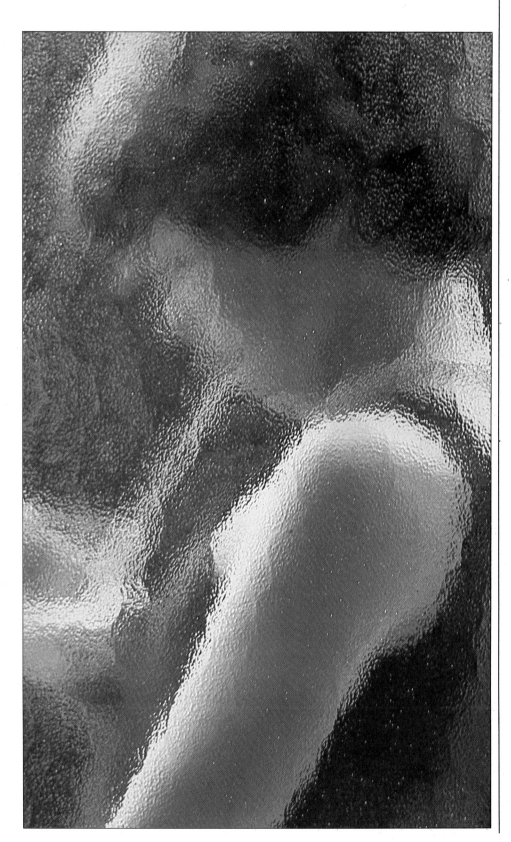

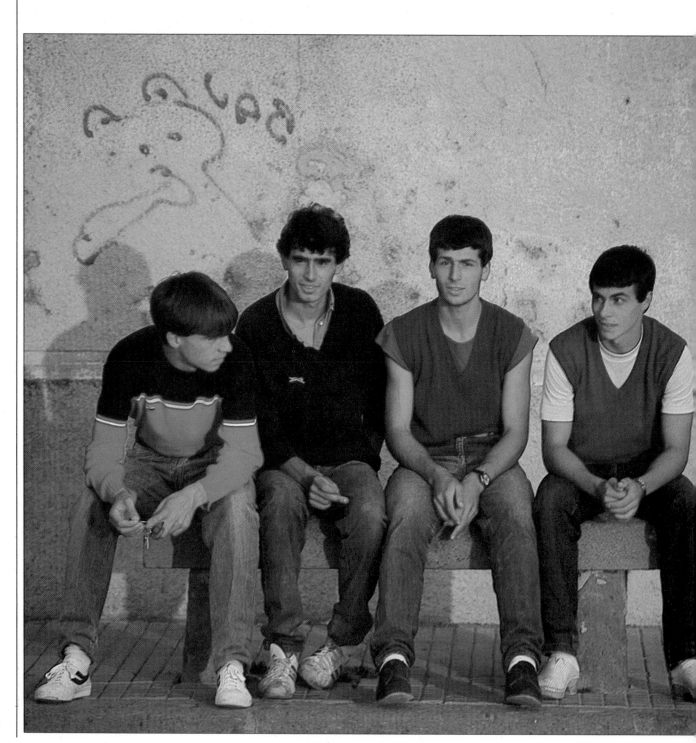

PEOPLE TOGETHER

People tend to feel much more relaxed in front of a camera when they are together than when they are alone. The onus of attention does not rest on any one person, and the close relationships within a circle of friends, or among members of a family, makes the whole situation more natural and less stilted. The interaction of several individuals can add depth of interest as well as spontaneity to the picture.

However, group pictures also put your photographic skills to the test. Simplicity – often the keynote of good photographic composition – is more difficult to achieve, if only because there are several elements in the picture, rather than a single dominant center of interest. The fact that your subjects are relaxing in one another's company can, if you are not careful, become a disadvantage rather than an asset, because their attention is more difficult to capture. And as a result, convivial gatherings that seem so full of opportunities for lively pictures can produce disorganized photographs.

The section that follows emphasizes the importance of planning in a great range of situations – from candid shots of couples to great formal events such as weddings. The real secret of photographing people together is to be technically and imaginatively in control of the situation.

Four buddies seem linked by more than their sneakers, jeans and youthfulness as the two outer figures look toward each other. In the simplicity and strength of this composition, and the sense of relaxed alertness, the picture shows how a group portrait should work.

Spontaneous groups

Often, the pictures that we tend to value most of friends are those that capture a particular moment of fun or shared company. The power of such images to evoke atmosphere and memories depends largely on a sense of informality – a lack of awareness of the camera. Such pictures are difficult to pose. But you can take advantage of natural groupings – a circle of friends in animated conversation, or a family playing together, as in the picture below. A good way to shape the composition is to concentrate on a small part of a large group, with one person as the center of interest if possible. To capture more of the scene, you will have to find a central point of interest to link the subjects. In the bottom picture on the opposite page, the fire provides a focal point for the two groups of people.

A telephoto lens makes it easier both to retain spontaneity by keeping your distance and to close in on the subject and exclude details that you do not want. Because you cannot hope to control the situation from a distance, you will need to plan intelligently. For example, in the baseball picture at near right, the photographer focused on home plate as the last runner came in. Then, by waiting until the team surged forward to lift the boy, he took the picture that tells the whole story. Similarly, the amateur photographer who captured his friends silhouetted in spray at a summer camp (opposite) anticipated the action as a water-skier approached the group, and by judging the shot perfectly achieved a sense of effervescent spontaneity.

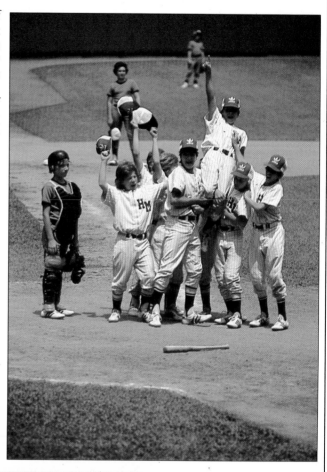

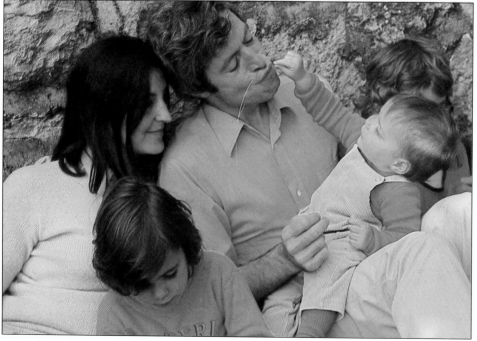

Victorious baseballers (above) instinctively struck this classic winners' pose as a home run clinched the win. A long-focus lens at narrow aperture kept the fielders fairly sharp, to give depth and contrast.

A father's game with his baby provides a strong point of interest in this charming image of a family on vacation. The photographer moved in for a compact view of their varied expressions against the background of a rock wall.

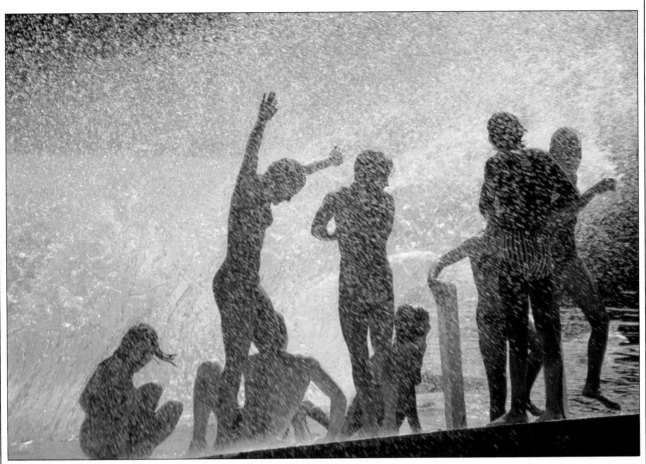

A water-skier showers youngsters on a jetty (above). The photographer, 75 feet away on the shore, saw what was going to happen. He set a 70-210mm zoom lens at its longest focal length, then waited for the spray to hit.

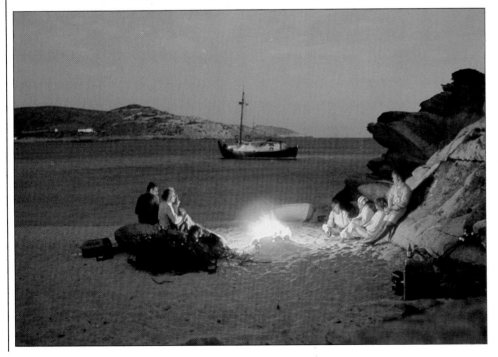

Isolated groups at a beach party are drawn together by the glow of their driftwood fire. A setting of 1/60 at f/2.8 overexposed the flickering fire and the faces, emphasizing the island of warmth in the cool surrounding twilight.

Arranged groups

When the purpose of a photograph is simply to convey an impression of people's sociability, it does not matter if the picture shows only part of a gathering, or if some members in a group are unrecognizable. But there are times when you will want to get everyone into a picture and to show them at their best. To do this, you will have to arrange the group.

How you organize a group will depend on the theme of the photograph, the location and the people involved. Consider all these aspects carefully before you set up the picture. An arranged group can look perfectly spontaneous if you plan the photograph that way. In the picture below, the photographer avoided a dull image by asking the children to run toward the camera. However, for bigger gatherings, such as a grand reunion between the members of a large family, a formal arrangement usually works better. You might place people in rows according to height, or group them around a central seated figure. A plain backdrop will keep attention on the subject, while a few strategically placed props can be used to suggest mood.

A formal composition does not mean that the people in a photograph have to look stiff or pompous. However momentous the occasion, the subjects should always look relaxed; otherwise, the picture will disappoint you and them. Allow people to chat among themselves until you are ready to begin shooting. This will establish a rapport and prevent the group from becoming bored. Give firm but cheerful directions, and do not move people around too much, or you will irritate them.

Most important of all, use plenty of film. There are two reasons for this: first, people will usually relax once they get used to the click of the shutter; second, you cannot hope to show everyone at his or her best in a single shot — as the two pictures opposite clearly demonstrate.

Children racing through a park show how an arranged group can be made to look natural. By telling them to run straight toward him, the photographer got a clear image of each child. The arrow formation pulls the group together and gives the picture a strong focal point.

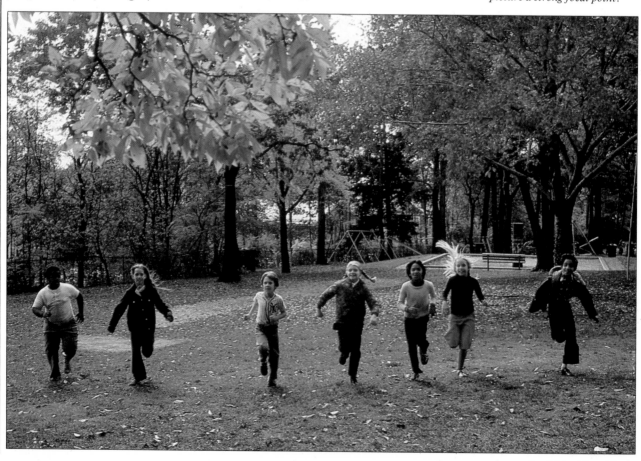

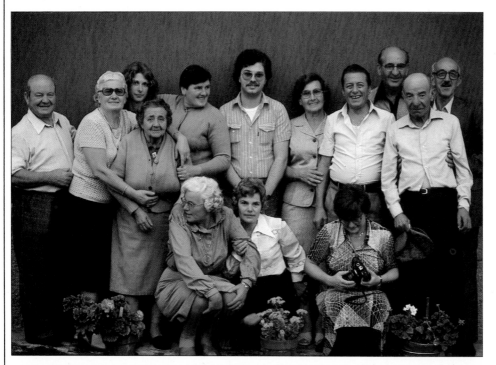

Changing expressions in
these pictures of a family
reunion show the volatility
of a group and the advantage
of making several exposures.
The group is more relaxed
in the lower frame, though
both pictures have a nice
formal-informal blend and a
firm sense of family unity.

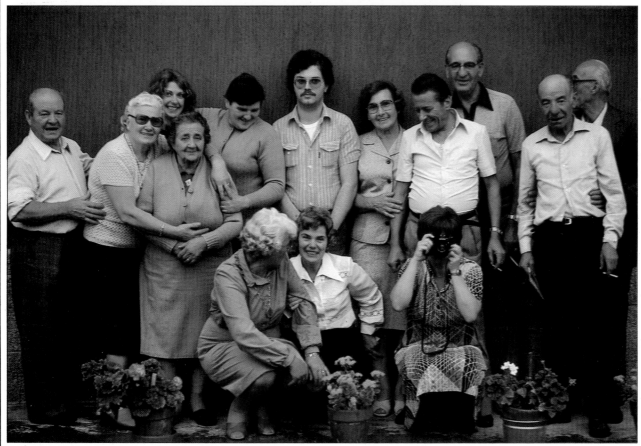

Around the table

Good food and good company may seem like a combination that guarantees great pictures. Joining in a meal – whether a family dinner, a casual lunch outdoors or a Thanksgiving feast – inevitably relaxes people and puts them in a contented mood. Nevertheless, photographing people at mealtimes does present a challenge. Indoors, the arrangement of a group around a table tends to be determined by the place settings, so that if space is cramped you may have difficulty getting everybody in the frame. At the same time, limited light may create depth of field problems because you are forced to use a wide aperture, and there may be considerable distance between those seated near the camera and those at the far end of the table.

One way of providing more light and using a narrower aperture is with a flash. But to avoid over-lighting part of the group and leaving others in shadow, you should bounce the flash off the ceiling or a light surface. Often, natural light or room lighting gives a truer atmosphere. You can reduce the depth of field problem by closing in on part of the group, as in the picture at the top of the opposite page, or by taking a high viewpoint, as in the extreme example at bottom right.

A wide-angle lens is nearly always an advantage when photographing meal scenes. The picnic scene below demonstrates how a 28mm lens's depth of field can show a display of appetizing food, an entire family and the river behind, all in sharp focus.

A generous spread awaits *a family picnicking by the river. The use of a wide-angle lens to get the whole group into the frame has distorted the foreground slightly: as a result, the brightly colored fruit and plates of salad look even more appetizing.*

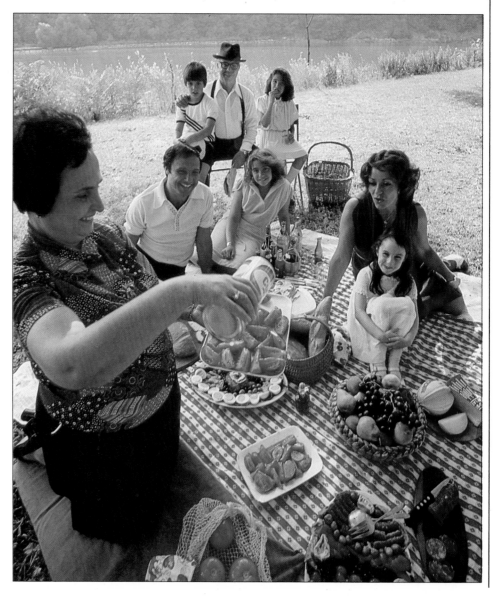

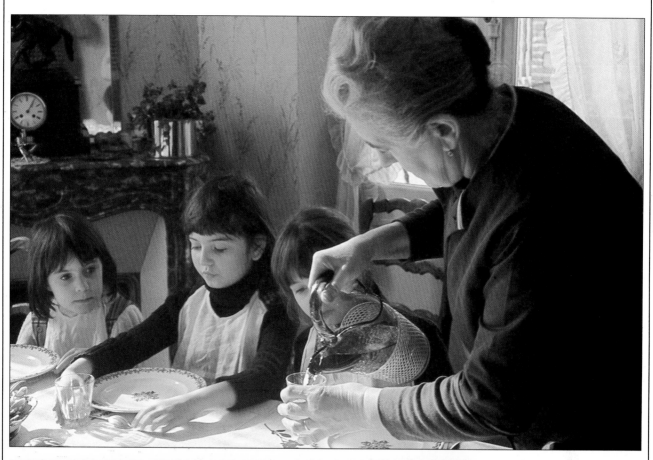

Expectancy on the faces of two little girls waiting for drinks forms a charming contrast to the third, who has been given a glass and now studies her empty plate.

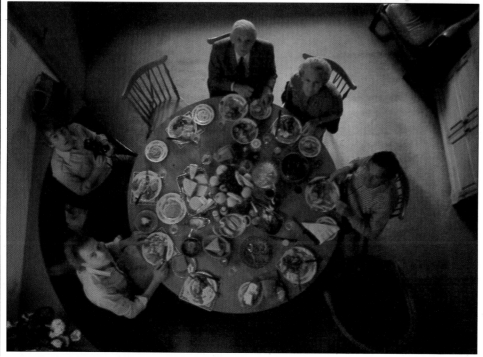

A holiday lunch party caught off guard by a photographer on a mezzanine above, forms a symmetrical pattern that shows off the meal the group is about to demolish. From this angle, a wide aperture could be used, giving just enough light for the fast film (ISO 400) to record the mixture of daylight and room lighting.

Wedding day/1

Usually there are several people taking pictures at a wedding, one of them a professional. But that does not mean that all the best picture opportunities have been taken. The professional is restricted by the need to record all the key moments in a conventional way – for example, the bride and groom signing the register or cutting the cake. And perhaps the other photographers, even the ones who are competent in different circumstances, forget their visual detachment in all the excitement.

If you want to photograph a wedding, some advance preparation is sensible, because you will have to work quickly. Modern ceremonies are usually over in less than half an hour, and nobody likes to be kept waiting about afterward while a photographer fiddles with equipment and agonizes over angles. Ideally, you should visit the church and the place where the reception will be held before the wedding itself. Ask for permission to take pictures during the ceremony, and find out whether the use of a flash will be acceptable. To avoid uncomfortable delays when switching lenses, plan to change lenses during lulls in the proceedings. Or better still, choose a single lens suitable for all the pictures that you expect to take. Often a normal or

slightly wide-angle lens is versatile enough to give good results throughout. The wide maximum aperture of such lenses also allows you to take pictures in low light – particularly inside a church – without a flash. The picture opposite, taken in a large and poorly lit church, used only natural light and the church's own lights.

For posed group pictures, try to find a flight of steps or some other sloping ground so that you can arrange big groups compactly but with all the faces visible. Group pictures are difficult to get right, but the secret is to be brisk, positive and good-humored. If possible, get someone from each of the two families to help organize people in front of the camera, leaving you free to concentrate on the picture. Try to position people so that they stand at a slight angle to the camera, with the outer figures looking toward the center. Save the biggest groups until last; adding people to a small group is easier than removing them from a large one.

Finally, be alert for more informal opportunities; they may give you the best results of all. The delightful picture below of the bride with one of her flower girls records one of those special moments that can be anticipated but never posed.

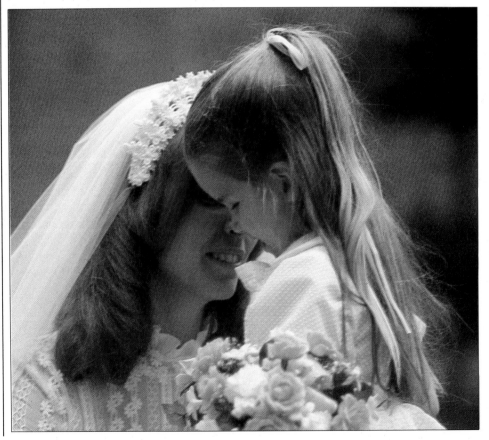

A flower girl gets a few words of praise. The photographer discreetly kept close to the bride prior to the reception, and was rewarded with exactly the sort of informal scene he had anticipated.

A high vantage point above the congregation enabled the photographer to use the formal grandeur of this setting to emphasize with a long lens the emotionally charged moment as a couple exchanged their marriage vows. He steadied the camera on a rail for an exposure of 1/4 at f/5.6.

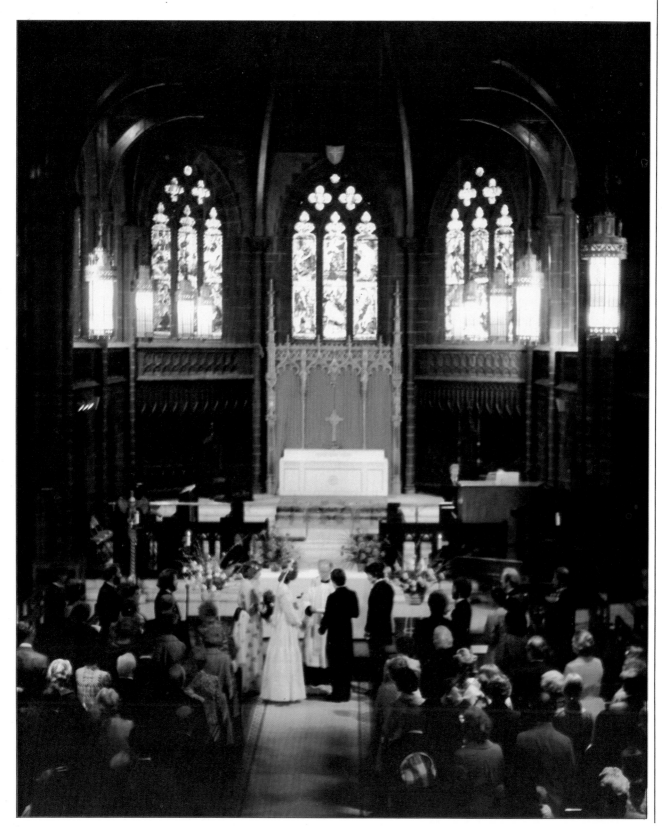

Wedding day/2

At a wedding, a photographer has few second chances – often there is just one opportunity to get everything right. However, there are some simple ways to reduce the risk of disappointment. One of these is the choice of film. Fast color print film (ISO 400) has exceptional tolerance to errors of overexposure, and its great sensitivity gives you the maximum chance of taking pictures indoors by available light, as in the beautiful example below.

In case the light in the church is too dim for a picture even with fast film, a small flash unit is advisable. Also, for portraits, extra light from a flash can help to reduce the tonal contrast between the groom's dark clothes and the bride's white dress: move the groom slightly closer to the camera than the bride, so the flash lights him more brilliantly.

If the weather is good, you will want to take some pictures outdoors. But try to photograph groups in the shade rather than making them face the harshness of direct sunlight. Alternatively, position them with the light behind, and take a close reading. If you have to take pictures in direct sun, be careful of shadows caused by hats. Either move the group so that some light falls on the faces or use a flash at reduced power to fill in the shadows.

Choose a moderately wide-angle lens rather than a normal lens. A 35mm lens, such as the one used for the picture of the bride at right, lets you get closer to the subject in a tight space, and also reduces the chance of a guest walking in front of the camera just at the moment of exposure and thereby ruining your photograph.

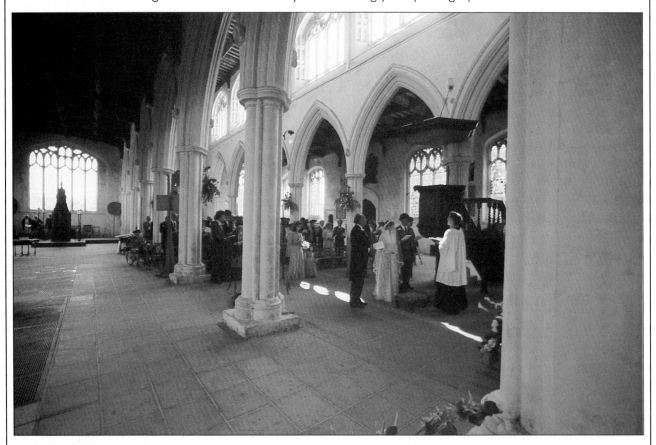

A sunlit church calls for careful metering. Here, the large windows and reflective white walls provided plenty of natural light, but the photographer gave one stop more exposure than indicated to compensate for the bright windows in the background.

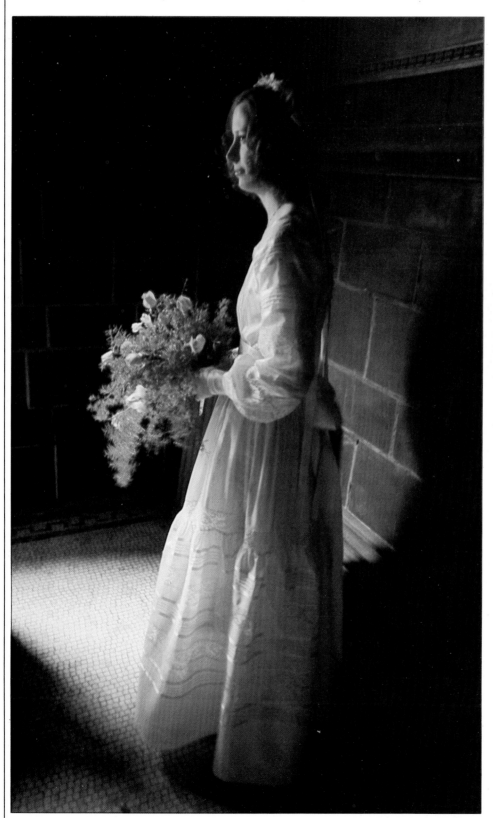

A nervous bride waits in the church entrance. Even in some large churches, certain areas tend to be relatively cramped. For this picture, the photographer had to use a wide-angle lens in order to encompass all of the flowing lines of the wedding dress.

A wedding cake sometimes appears as a featureless white shape if the picture is taken with direct flash on the camera. To avoid this, the photographer pointed the flash at a white wall on the left, to soften the light, and opened up two stops.

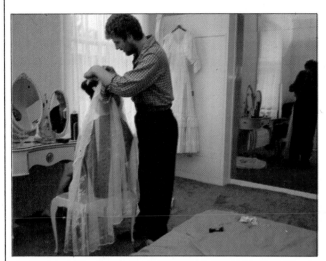

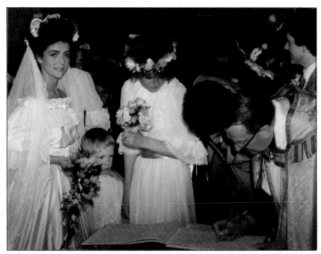

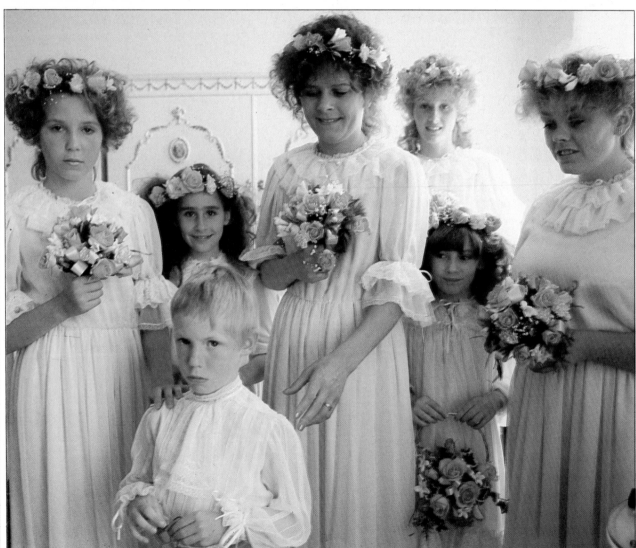

Wedding day/3

Whether or not you are the official photographer, you are likely to use up more rolls of film at a wedding than on any other family occasion. One way to deal with the sheer volume of subject matter is to treat the event as a photographic essay. Instead of ending up with a heap of disparate images, you will have a clear, sequential record of the big day, which will look impressive either in an album or when presented as a slide show.

Because most weddings progress in a similar way, you can readily plot out the main events – the high-points of your essay – well in advance. Use the prearranged length of the ceremony itself and the time at which the reception is due to start as fixed points, and calculate the other timings around them. Dividing the day into stages – the preparations at the bride's home, her arrival at the church, the service, the reception and so on – will also help.

The photo-essay will obviously center around the bride and groom, and you might construct a mini-sequence based just on them. But the full story should include the peripheral characters too. At every stage of the proceedings, try to vary the style and content of your pictures. For example, as well as the traditional view of the bride putting on her finery, photograph her anxious father pacing the hall and looking at his watch. A useful tip is to make sure you take some photographs to link the different stages of your essay. Location shots can serve this purpose. A simple photograph of the church exterior could provide a smooth transition between a picture of the bride's family setting off in their cars, and an interior view looking down the aisle past the ranks of waiting guests.

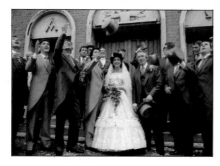

A variety of backgrounds and groupings will sustain the freshness of a picture-essay. The photographs here, selected from a longer sequence, start with nervous preparations at the bride's home (left and top left) and end with the couple's laughing departure from the church in an open carriage. Natural daylight, flooding softly through net curtains into pale-colored rooms, was perfect for the informal picture of the bride with her hairdresser and for the splendid study of the bridesmaids with a nervous page boy. The photographer sought advance permission to use a flash for the picture as the couple signed the register, and angled the light so as to avoid flat lighting.
To achieve the relaxed sense of fun in the picture above, he asked the best man and the ushers to throw their hats in the air as the ceremony ended.

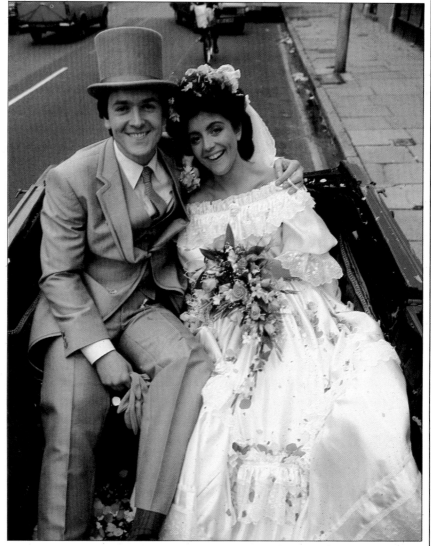

Pictures at parties

A party is rarely a time for carefully staged pictures. The best visual moments tend to happen without warning, and the exuberance of most celebrations demands a quick eye and a ready camera.

Technically, to some extent your approach will depend on the party's size, tempo and setting. For example, the hard light of a flash unit may not suit a small, quiet birthday gathering at home. In the picture below, the photographer has kept the atmosphere of the occasion by using only the candles on the cake to light the subjects. However, amid the anonymity of a masked ball, a flash goes unnoticed.

Sometimes, special techniques are useful when a party livens up. By deliberately choosing a long exposure, or by zooming a lens during the exposure, as in the picture at the top of the opposite page, you can use blur to suggest the whirl of a dance. While flash freezes the important part of the subject, the room lighting will record some blurred movement. And you do not necessarily need a tripod.

An exhausted couple sitting out a dance can evoke the occasion just as strongly as an action shot – and will allow you to compose the picture more carefully. The beginning and end of a party, too, can provide interesting images, particularly if you can show amusing contrasts – perhaps a pristine buffet table compared with the battlefield of a few hours later. Three important guidelines will stand you in good stead at any celebration: use a fast film, set the smallest possible aperture for maximum depth of field, and preset the focus. Then you should be sure of capturing the mood of the event.

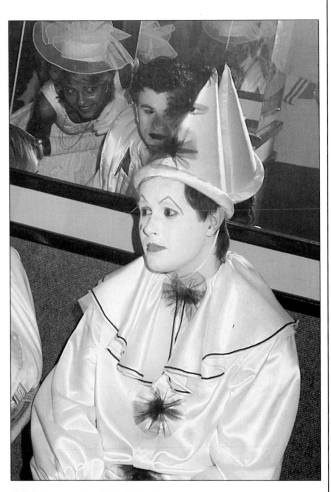

A costume party combines mischief and mystery, and in the picture above, the photographer has artfully conjured up the atmosphere by focusing on reflections intriguingly repeated behind the head of the pierrot.

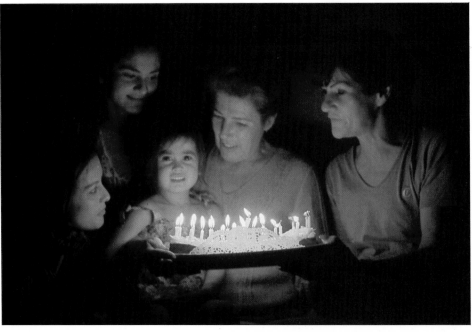

Family members around a cake (left) appear softly from the darkness during a birthday celebration. The evocative glow of the candles, which draws attention to the pattern of faces, was captured with an exposure of 1/8 at f/2.

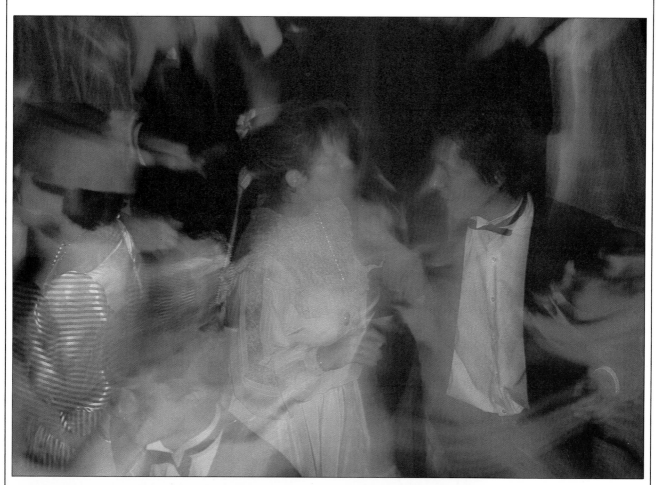

Dancing couples at the formal party above merge into swirls of color. The photographer used a flash and changed his zoom lens focus during a 1 sec hand-held exposure to convey the head-spinning momentum.

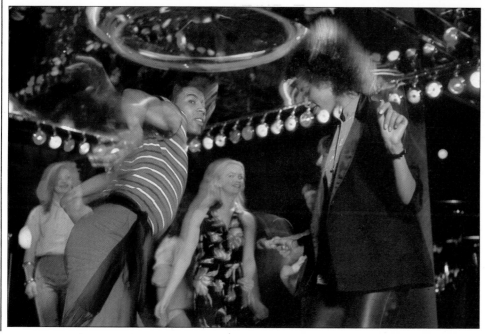

Strident spotlights echo the din of a disco (left) in a picture taken at a shutter speed of 1/2 to record the blurred mixture of tungsten and stroboscopic lights. The photographer got low, bracing the camera with his elbows.

Loving couples/I

Good pictures of people in love have a special kind of emotional charge, an intensity of feeling that is unmistakable and very attractive. Whether or not you can capture this depends partly on recognizing that each couple's relationship is unique. People express their feelings for each other in a thousand small ways, from the touch of a hand to a trusting glance. They may display their shared affection flamboyantly, or reserve it for moments when they are alone. Some are teasing and playful, and others prefer serious conversations and companionable silences. As a close friend or relative, you have the chance to observe the style of a relationship, and this knowledge of the couple can be a great advantage in photographing them without making them feel self-conscious and thus spoiling the atmosphere.

To evoke these special emotions, you need not have the pair facing the camera, or even show both of them fully in the frame. Moreover, you need not be solemn about the picture. The two very different photographs here have in common an unusual and lighthearted approach to the subject. Little can be seen of the couple in the deck chairs, yet every detail of the composition, culminating in the joined hands, spells out their partnership. The half-joking symmetry reveals a degree of planning that required the willing cooperation of the photographer's friends. In the picture opposite, the girl is also aware of the camera and completely relaxed. Close framing with a telephoto lens crops the man out almost entirely – his arm curling around the girl is the only detail needed to convey the joy of their relationship.

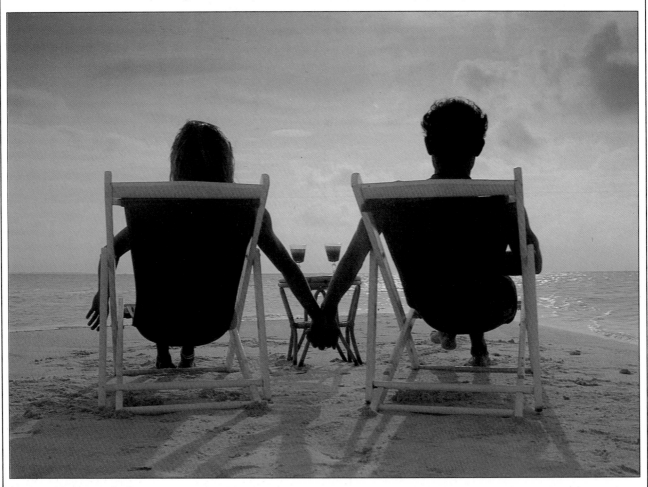

Clasped hands, paired glasses, and backs turned toward the camera are the photographer's affectionate commentary on two friends who wish to be alone.

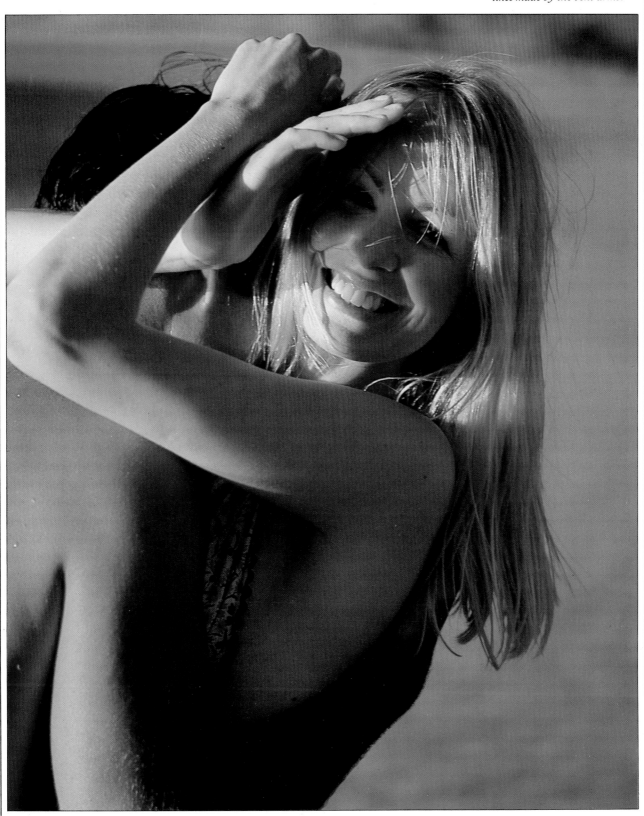

Enfolded in an embrace,
a girl reacts with a smile
that extends to the corners
of her eyes. Careful framing
accentuates the strong diagonal
lines made by the bent arms.

Loving couples/2

Some people in love seem to inhabit a world of their own in which those around them become almost invisible. Their mutual absorption may offer you opportunities to take pictures that are completely candid and that explore the private side of a relationship rather than the image a couple present in public. Pictures as personal as the one below seem to give us a privileged glimpse of love itself – the couple are so involved with each other that the photographer could move in very close without

breaking the spell. Because mood is more important than sharp definition – and because the light is unlikely to be strong – fast film is best.

However, you can express intensity of emotion without closing in on a couple; indeed, distance can help to evoke the feeling, as the two pictures on the opposite page show. Although the subjects themselves are indistinct, the pastoral settings, muted colors and gentle light all help to establish a dreamy, romantic mood.

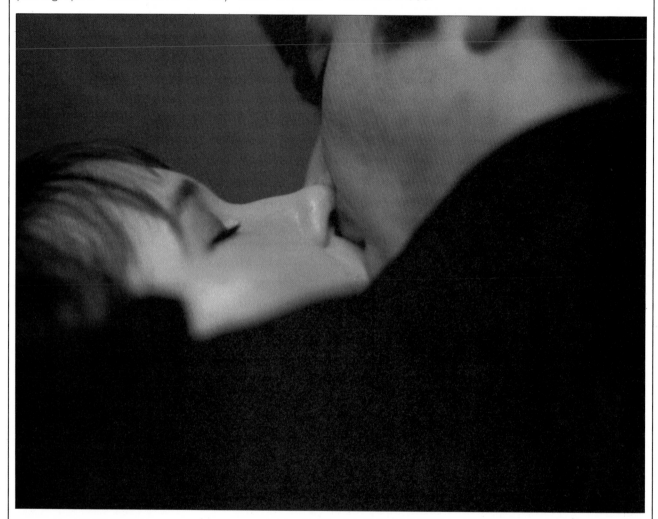

The intensity of a kiss
seems to suffuse the whole of
this sensitive photograph.
The grainy quality of the
image – the result of using
ISO 400 film, then allowing
extra development – softens
the couple's features and
adds to the atmosphere of
intimate tenderness.

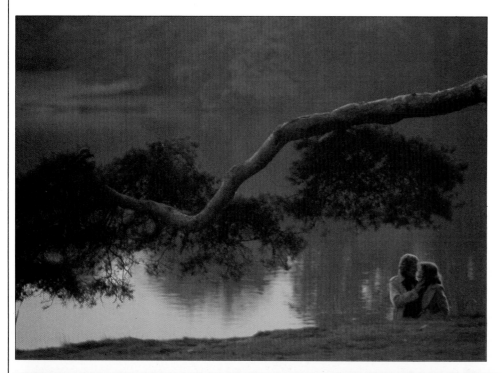

Reflections *of the setting sun cast a gleaming aura around the silhouettes of two lovers. The rimlit bough hanging over the water and the steep bank provide an interesting frame for the couple against the soft tones in the background.*

Arm in arm, *a couple stroll across a meadow. The open space surrounding the pair suggests a tranquil closeness, and by choosing a distant view of their backs, the photographer has avoided intruding on them.*

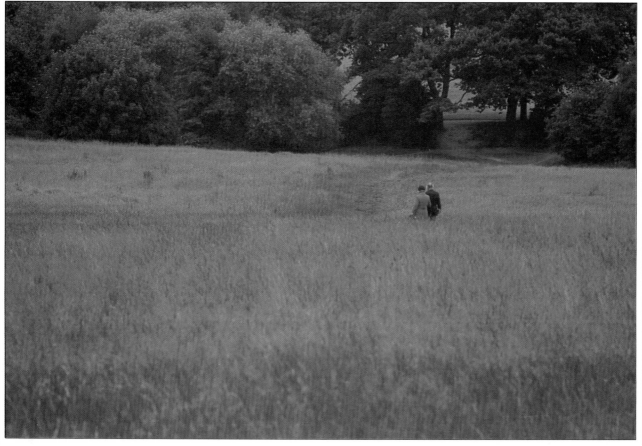

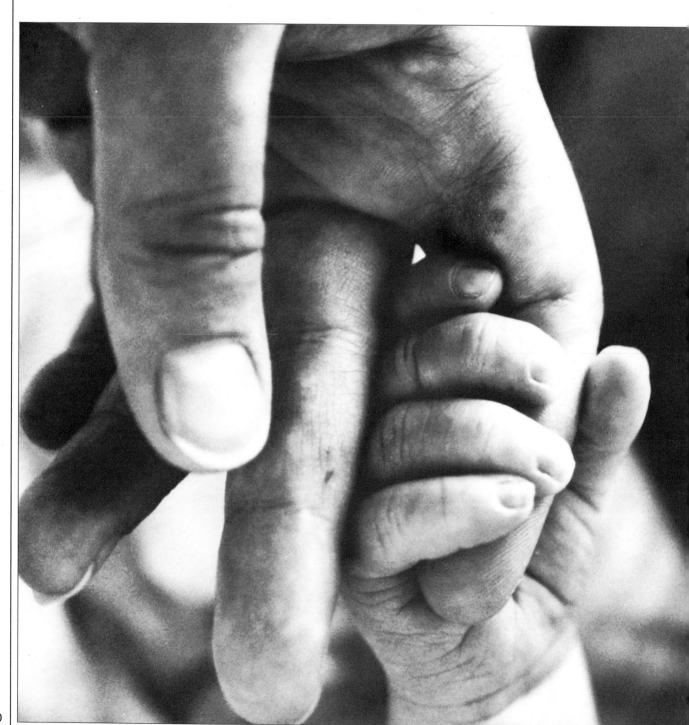

CHRONICLING THE FAMILY

Most families have a photograph album. The starting point may be a couple's wedding day, or the birth of their first child. As children grow up and the family circle widens, a rich pictorial biography slowly unfolds – almost like a story that begins simply but develops an intricate plot as new characters appear.

Over the years, you will almost certainly build up a collection of images capturing the key moments in your family's history: a baby's first smile, and all the other milestones of growing up, punctuated by ceremonies such as birthday parties and anniversaries. But you will get much greater satisfaction, leafing through the album in later years, if you include everyday moments alongside the special occasions, and if you balance conventional shots with unusual and original ones.

This final section shows how you can give visual as well as emotional impact to each page in the family album. There are suggestions to help you find fresh, imaginative approaches for documenting every stage of family life. The techniques and ideas here, together with your own inventiveness, can enable you to maintain a record that will give renewed pleasure to everyone who sees it.

A tiny hand grasps a father's finger, huge by comparison. The photographer used the close-focusing ability of a normal 50mm lens for this telling image. Careful framing included the baby's face in the background – deliberately out of focus to concentrate attention on the expressive pair of hands.

Parent and child

The emotional ties between parent and child are profound, but not always obvious. As a result, you may find pictures that clearly express the closeness of a relationship more difficult to take than you might have expected.

A straightforward way to translate the parent-child relationship into visual terms is to choose a moment of physical contact and then close in for a head-and-shoulders shot. You could either use a telephoto lens to frame the picture tightly, or exclude the surroundings by moving in with the camera. This approach will certainly be suitable with smaller children, who are often carried or cuddled in the arms of a parent and who will be at ease in this familiar pose. However, older children who are

less demonstrative may not enjoy being forced into such a situation. You may get a more natural picture by simply waiting for a moment when parent and child are looking at each other. Often, eye contact expresses closeness as powerfully as does physical contact — for example, in the picture below, where a father and his daughter are so wrapped up in conversation that they are unaware of the camera.

A parent and child playing together or sharing some other activity often become similarly absorbed, again enabling you to take pictures that are completely spontaneous. To avoid interrupting them, use a telephoto or zoom lens. A fairly fast shutter speed will also help, allowing you to capture the best moments in the action.

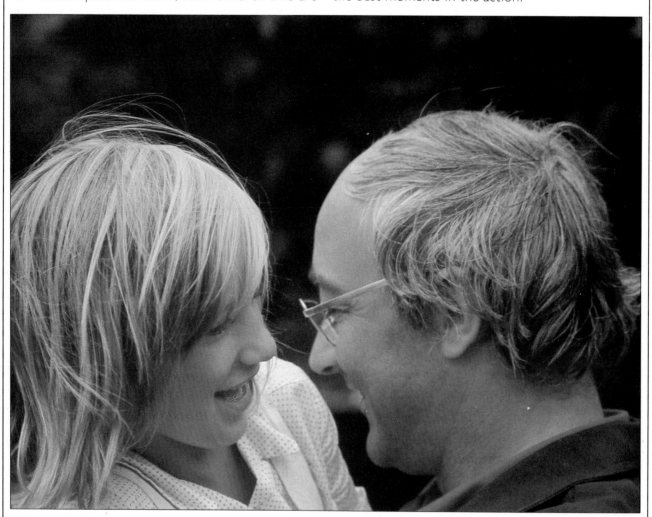

Father and daughter communicate interest in each other unmistakably by their close and loving smiles. The photographer used a 135mm lens to move in and concentrate on the faces.

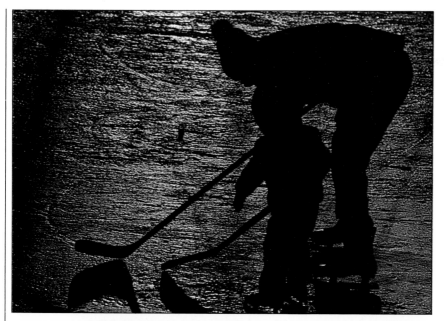

A first hockey lesson makes a revealing study of parental care, even though the figures are seen only in silhouette. With the light from a low sun glinting on the ice behind the subjects, the photographer gave two stops less exposure than that indicated by the camera's meter. This achieved correct exposure for the ice but showed the hockey players as dark shapes.

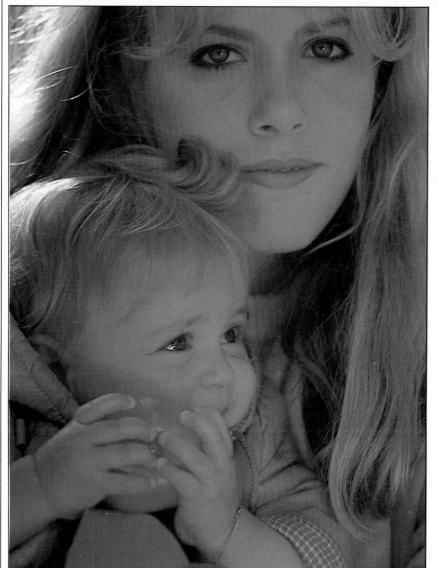

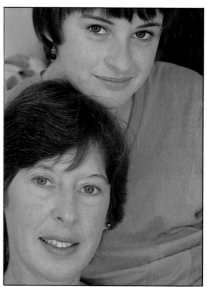

The family resemblance is so strong between the mother and daughter above that their two faces, superimposed, seem to express their whole relationship. Broad light from the windows of a well-lit room gives a flatteringly soft effect.

In her mother's arms, a girl (left) smiles prettily away from the camera – although still a little anxious at being photographed. Close framing helped to exclude bright light from the exposure.

Baby portraits

Babies change and grow so quickly in the first few months of life that the camera's capacity to stop time takes on a special value and importance. Little wonder, then, that some parents keep a week-by-week photographic record of their tiny children. Many such pictures of babies are of interest only to the mother and father, or a close relative, but others have a universal attraction because they appeal to the parent in all of us.

The images that most often strike a chord are those showing some kind of activity, rather than a static subject. All but the very youngest children are acutely aware of the world around them, and even a one-month-old baby's eyes will follow an object moving above the crib. Try to capture this naive attentiveness in your photographs. Because babies concentrate most fixedly of all on their mothers, you have a better chance of taking good pictures if you enlist the mother's help. She can keep the child relaxed and happy, and, by diverting attention away from the camera, will make the situation look more natural. If necessary, she can also support the baby inconspicuously in the position you want.

As a child's coordination increases, so does the variety of picture possibilities. After a few months, babies begin to react with intense interest to what they see, and there are opportunities for such touching pictures as the one on the right of the opposite page. This kind of spontaneous image is often the result of a patient wait – and parental familiarity with a child's habits and reactions.

Because children of this age are so tiny, you can usually find a suitable setting for the picture – one that does not compete for attention with the subject. Look for a simple background, such as the wide, almost featureless expanse of a double bed. A textured bed cover will provide a subtle contrast with the perfect smoothness of the baby's skin.

Diffuse natural lighting will emphasize a baby's unblemished complexion, and is less upsetting than the sudden burst of illumination from an electronic flashgun. Try to arrange the picture so that light falls on the baby from the side and from a window that is not in full sunlight – direct sun causes deep shadows, and often results in a picture that shows the baby with pinched features and screwed-up eyes. Fast film will give you most flexibility; both the pictures opposite were taken with ISO 400 film.

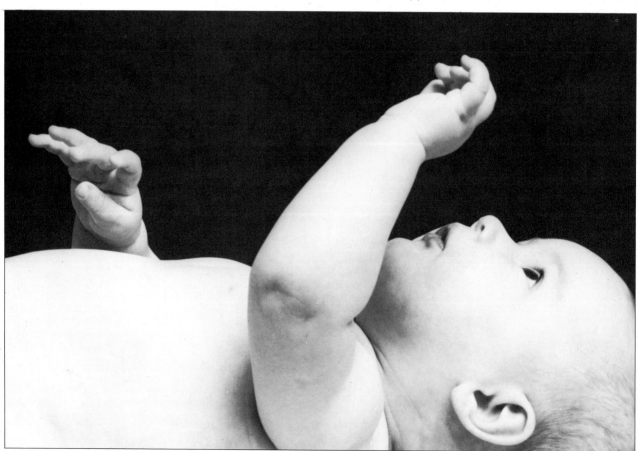

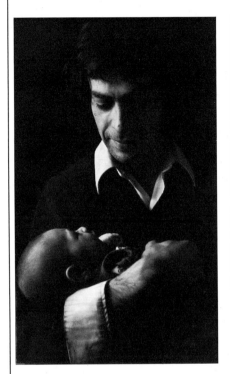

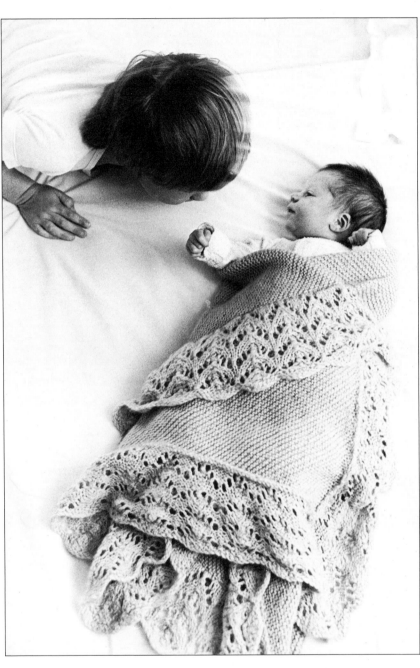

A babe in arms is completely helpless. In the picture above, the photographer emphasized this complete reliance by framing the composition so that the father's arm forms a strong base. The shutter, set at 1/60 with an aperture of f/2.8, was released just as the eyes of the father and child met.

The soft, rounded shape and chubby hands of a three-month-old girl (left) stand out against a black background, which the photographer arranged by hanging up a piece of velvet. Then he knelt down by the bed for the picture. You should avoid framing such pictures too tightly while composing the shot, in case the baby moves out of the frame. Instead, take a somewhat wider view and then have the print cropped closer.

An older brother inspects the latest arrival. By choosing a high viewpoint, the photographer was able both to show the interaction of interest, and to use the knitted shawl as a richly textured element in the composition. The white bedsheet serves a dual function as a plain background and as a reflector to bounce some of the light from a window back into the shadows. Even so, the picture needed a slow shutter speed of 1/15 at f/4.

Toddlers/I

Toddlers have none of the inhibitions that often make it difficult to photograph adults. In fact, the main problem is keeping them at arm's length for a photograph. Like any glittering, shiny object, a camera appeals to a child's curiosity, and if you are not careful you may find your lens covered with small sticky fingerprints.

You can get around this problem in several ways. The simplest is to use the element of surprise. Because young children become totally absorbed in activity, you should find it easy to sneak up unobserved. Before you get anywhere near, set the camera's exposure controls to suit the prevailing light, and prefocus the lens for a distance of about three feet. Move in quietly until the viewfinder image is sharp, and then attract the child's attention before releasing the shutter. The wide-eyed expression of surprise on the face of the child in the small picture below is typical of the spontaneous reactions you can capture.

Another technique is to use a telephoto lens and compose the picture farther away from the toddler. This has the added advantage that the increased distance between you and your subject results in a more accurate perspective. Children's heads are bigger in relation to their bodies than are adults' heads, and a normal or wide-angle lens can sometimes exaggerate this. A telephoto lens restores the balance and give a more natural effect.

The camera position also affects perspective and proportion. Seen from above, children's heads are closer than their feet to the camera – and therefore look bigger on film. Rather than standing up to take the picture, try kneeling or lying on the ground to produce a more intimate and revealing child's-eye view of your small subjects.

Sucking her thumb, a little girl stares with surprise at her father's camera. For taking pictures such as this by available light indoors, a medium-speed film such as IS0 100 is not sensitive enough. Instead, use an IS0 400 film so that you can freeze the child's movement with a fast shutter speed, instead of having to resort to a flash, which can be alarming if the burst of light is unexpected (1/125 at f/2).

A sunlit deck chair seems as big as a hammock to a two-year-old boy (right). The photographer successfully conveys this sense of scale by composing the picture in such a way that the top of the chair hides half of the child's face, and the striped fabric envelopes his body.

On the seashore, this little girl is relaxed for the camera. By getting down to her level, instead of standing up, the photographer has made a more intimate, natural picture, and included the surf and horizon in the background.

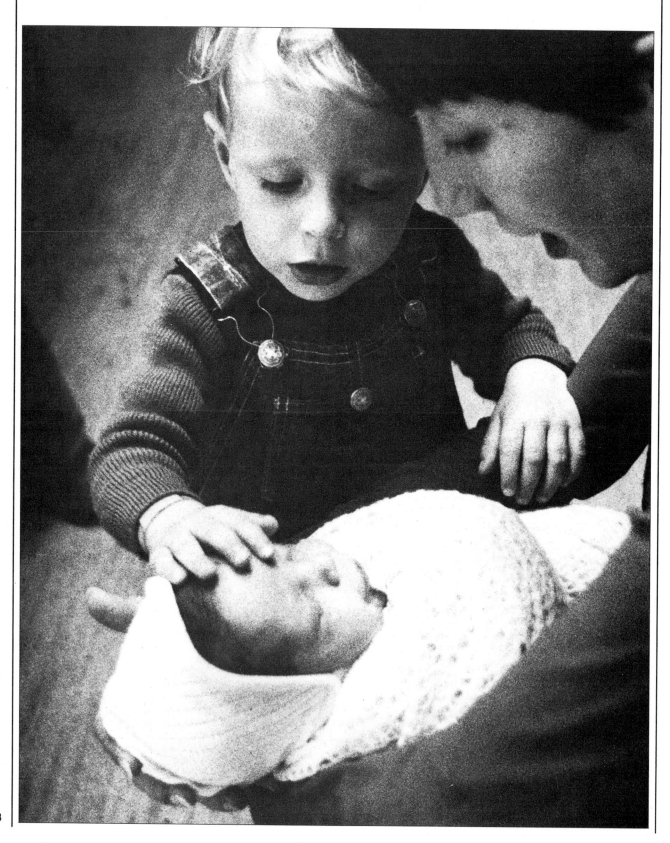

Toddlers/2

Adults often forget how large and strange the world looks through a toddler's eyes. Life is a constant adventure – the back of a chair is a head-high wall, and the inside of a cupboard a mysterious cavern. Photographs that suggest this strangeness have a special, reminiscent appeal.

Children explore their environment with single-mindedness, but their concentration lasts only a short time. Accordingly, when you see a child absorbed in some activity, take the picture quickly without pausing to direct the child – any distraction from you will break the spell. One special example of a child totally involved in a new experience is seen in the remarkable picture at left – a little boy encountering a new addition to the family for the first time. A more common opportunity occurs when toddlers become acquainted with one another, mingling suspicion and delight, as in the example on the right below.

If you want to show a child at play, you can easily enough set up a picture situation by providing a new toy. But the pictures may be more original – and amusing – if the "toy" is an ordinary household object, such as a telephone. To convey a sense of sharing in the child's experience, take the picture from a low viewpoint. A zoom or telephoto lens will help by allowing you to keep your distance. Choose a well-lit area so that you can freeze movement with a fast shutter speed (at least 1/250) and still select a small aperture. This will give adequate depth of field so that the child can move about without forcing you to refocus constantly.

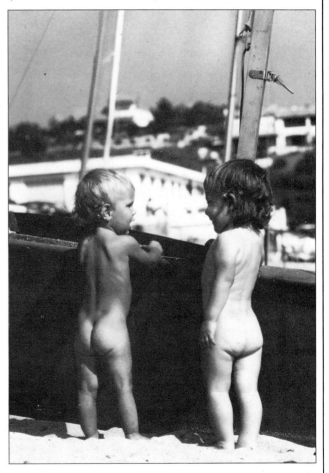

Hello, little brother – the first meeting with a new baby (left) creates a memorable image. Perfect framing and shallow focus concentrate attention on the little boy's expression of wonder.

Boy and balloon are framed unconventionally – but with good effect. Closing in on the subject with a zoom lens, the photographer has caught in the boy's expression some of the wistfulness of childhood.

Making friends, toddlers eye each other with cautious curiosity. By lying down for a low camera position – at toddlers'-eye level – the photographer has conveyed the scale of their world.

Little children/1

Every day of childhood is crammed with things to learn and discoveries to make. The mercurial moods of children and their boundless energy, as they pass from one fascination to the next, make them irresistible subjects for photographs. One minute a child will be poring quietly over a jigsaw puzzle or creating a painting; the next, cartwheeling across the lawn or rolling down a bank.

These two pages show what marvelous photographs you can take if you have a camera ready to catch children in all their changing moods. Assembled in a family album, a series of such pictures will become an irreplaceable record of a child's developing skills and interests.

Often, a single, well-judged image can sum up a phase in a child's life, or a particular aptitude. In addition, try building up sequences of pictures, taken either at one time or over a period. For example, you might take a series of photographs of your child learning to ride a bicycle – from the first wobbling attempts to the moment of hard-won success. Any achievement, small or large, merits a place in a pictorial record of a child's growth.

As play becomes more excited, you may be taken into the realms of true action photography. Good sunlight allows you to use the really fast shutter speeds needed to freeze fast movement – 1/500 or 1/1000. The young skier's expression of glee as she flies through the air (right) shows what you can achieve by using the techniques of the sports photographer. The photographer used a speed of 1/1000 and took several practice shots beforehand.

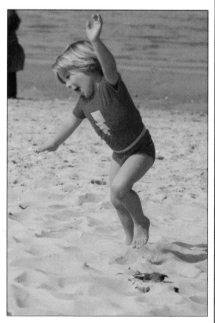

Jubilation at the seaside prompts a young boy to try out his cartwheels in the soft sand. The bright light enabled the photographer to combine a small aperture, for good depth of field, with a fast shutter to stop the action (1/500 at f/8).

A budding artist loads his brush with fresh color. The photographer centered on the well-used box of paints and the fingers carefully holding the brush, and framed the scene to include a large part of the painting as a colorful backdrop.

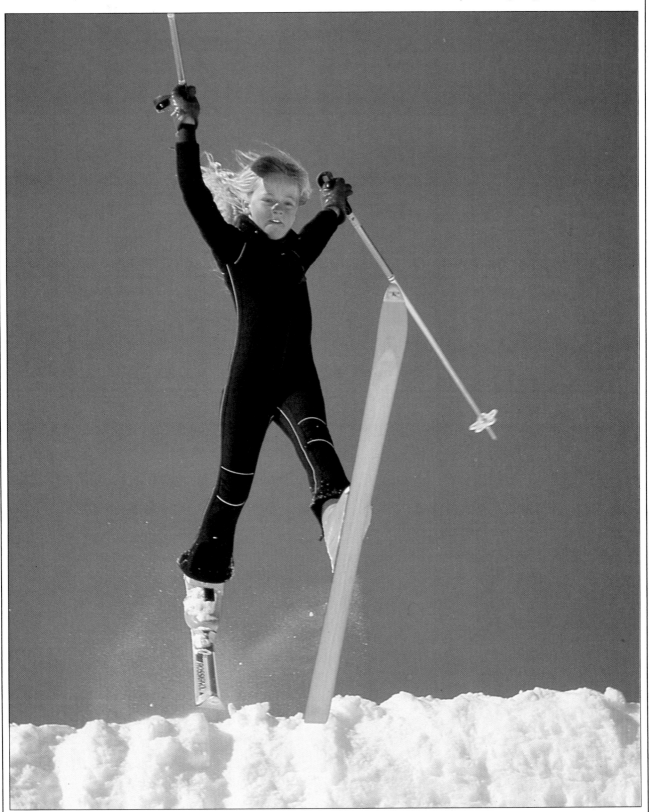

Face aglow, a practiced young skier fearlessly tests her hotdogging skills in a split jump. The photographer lay full-length at one side of the snowbank to exaggerate the height of the jump and frame the girl against the sky.

Little children/2

One of the most charming qualities of children is their lack of guile. Their faces register thoughts and feelings with absolute candor. For this reason, close-up photographs of youngsters, preferably taken during their quieter moments, can make revealing and enchanting character studies.

To get the best results from this type of picture, you should spend some time planning the composition. Find a simple setting that will suit the child's personality and experiment with different view-points. Because you will be concentrating on facial details, well planned lighting is important. Indoors, soft directional light is best – or backlighting, if there is also some reflected illumination to prevent complete silhouetting.

Finally, you will need your subject's cooperation. Settle the child in position with something to absorb his or her attention. Pets are especially suitable, and can also strengthen the theme of a picture, as the dog does below, unconscious of the camera.

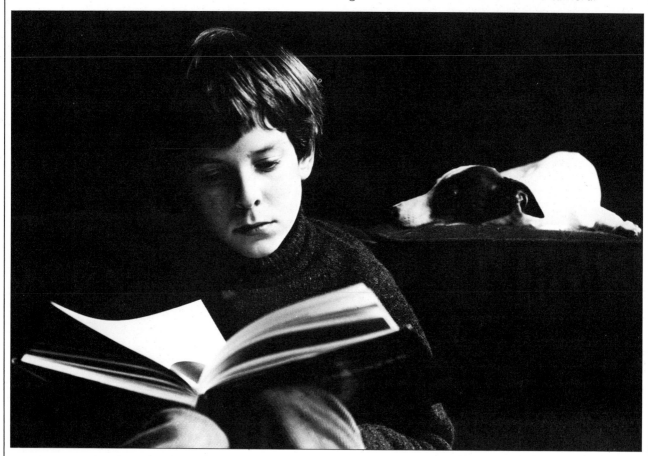

A browsing booklover and his sleeping pet have created an image of tranquil contentment. Seeing how complementary the pair were, the photographer angled the picture to suit them both. The open book acts as a reflector for the light.

Girl and cat *are transfixed by each other's unblinking gaze. Backlighting was crucial in order to obtain this rare study of a child's inquisitiveness: the light gives good modeling to the profiles and ensures that the eyes have a soft gleam.*

Brothers, sisters and friends

Most children are naturally gregarious. Surrounded by their brothers and sisters, or among their friends, their confidence blossoms. Whereas a child alone may be painfully awkward in front of the camera, several together may delight in performing for you.

Often, getting a good picture of children together means finding a midpoint between an overly formal pose and the disjointed effect of allowing the subjects total freedom. With a large group, a useful technique is to arrange them in a fairly structured way, and then wait for them to break the pose. Enough of the original formation will survive to give shape to the image, but the effect will be lively and spontaneous. Another approach is to encourage a boisterous game, joining in at first but then slipping away to take some pictures when the fun becomes unstoppable. Usually you will not need to contrive the action; children playing together will soon present you with a lively composition.

The developing relationships between children are a rewarding aspect of childhood that you will want to include in the family album. If you have more than one child, the emotional closeness, the shared joys and the little dramas of brothers and sisters will have a special meaning to you. To capture these moments on film, a telephoto lens can prove particularly useful – perhaps a 135mm or 200mm telephoto, or a 80-200mm zoom lens. With these, you will be able to close in on the children's private world from a distance and catch intimate expressions, as in the picture of a sister and brother at the bottom of the opposite page. Try to set them against a plain background, or else wait until the children are close together to frame them tightly.

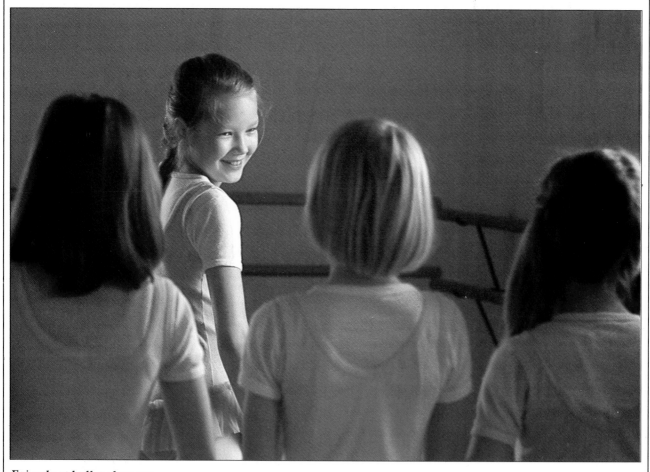

Friends at ballet class rest *before practice. The careful composition focuses on one particular girl, but the angle of her gaze directs the viewer to the others in the group.*

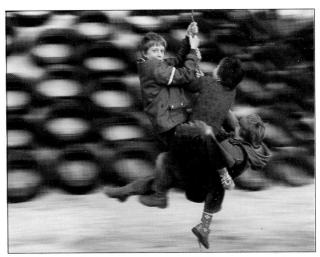

Boys show off their daring at an adventure playground. By panning the camera at 1/30, the photographer kept the main subject's features sharp and conveyed the action.

In mock aggression, a girl responds to her brother's teasing grab at her mirror. The closeness of the two smiling profiles points up the family resemblance.

Growing up

Adolescence is both an exciting and a troubling time, a real challenge to record on film. Children begin to express their individuality more assertively than ever before – something that can have negative as well as positive aspects. Teenagers can show boundless energy and enthusiasm, or they can become listless and withdrawn. Struggling to find an identity free from the world of childhood yet inde-pendent of an older generation's ways, they adopt attitudes, modes of dress and even behavior that parents find hard to understand or accept. But all this is part of the necessary process of breaking away in order to grow up – a process that you should try to capture in photographs. To reflect this perplexing time of life faithfully, you need to be sensitive to the rapid changes of adolescent moods, and corres-

A teenage couple are all confidence, only half aware of the photographer. Their clothes and manner, together with the setting in a garage entrance, establish the mood. To take such revealing shots, even of your friends or family, you will have to shoot quickly so that the subjects do not become self-conscious.

pondingly flexible and informal in your approach to photographing them.

Usually there is little point in trying to pose adolescents. They will quickly become bored or self-conscious. Sometimes, this may be the mood you want to show. But for more natural images you may have to look for opportunities when your subjects are not aware that you are going to take a picture, as on the page opposite. Teenagers like being photographed with a close friend, with whom they can share a sense of identity, or else in groups, when they are often at their liveliest. With such willing subjects, catch the spontaneity of the situation by shooting quickly and, if necessary, leaving the details of pose and framing to chance, as in the picture of students at the bottom of this page.

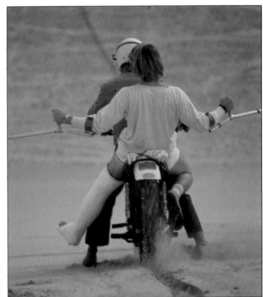

Two girls look toward the camera with remarkable candor (far left), reflecting their complete trust in the photographer, their mother. The lighting is soft, the pose careful but unforced.

A broken leg does not deter the motorcycle passenger (left) from displaying his youthful bravado for the benefit of the camera.

In a boisterous mood, a group of students jostle to be in the picture below. A spontaneous approach often produces the best pictures of teenagers.

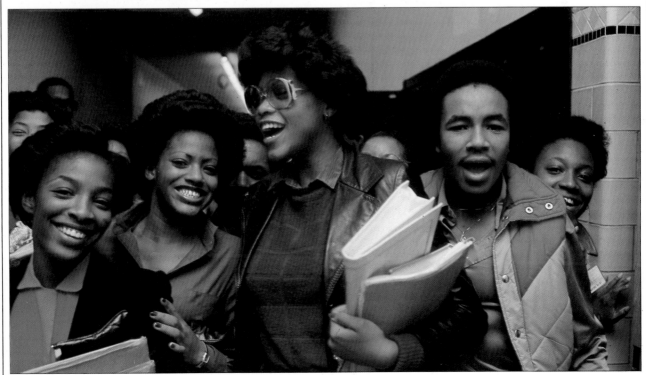

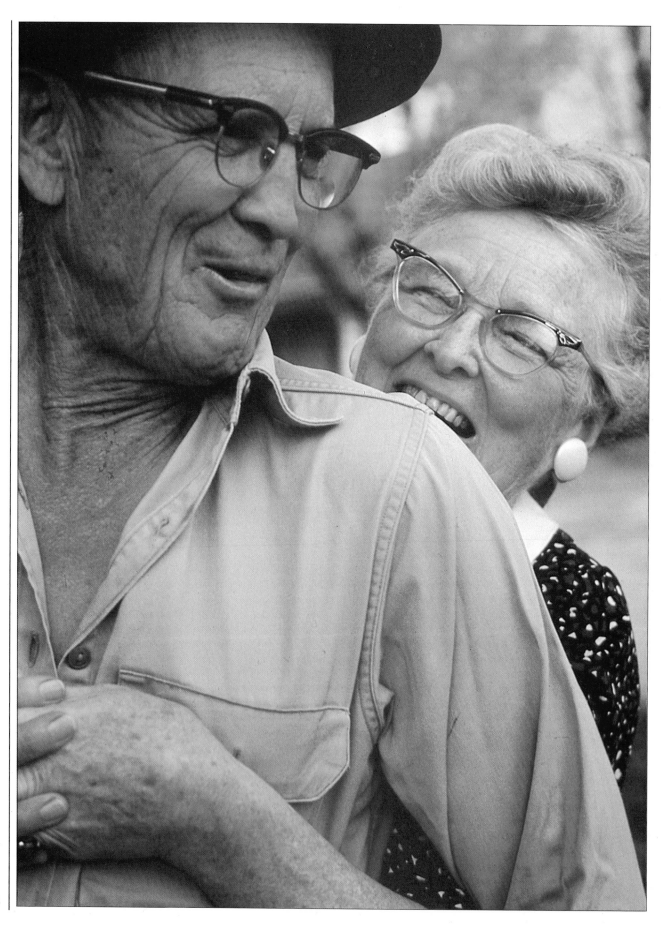

Parents and grandparents

Stereotyping is a special pitfall to avoid when taking photographs of the senior members of the family. Without thinking, we tend to portray the father as the head of the household, cast the mother in the caring role, and accord grandparents a sedate setting that befits the dignity or frailty of their years. You will produce more interesting pictures – and please the subjects too – if you regard older relatives not in terms of their family positions or as representatives of a type-cast generation, but as individuals, each offering different photographic possibilities.

Remember that your family has a life outside the home. The most expressive pictures of parents and grandparents are often taken when they escape their domestic surroundings. Pictures of a grandfather striding across the golf course or, as here, a grandmother riding her bicycle remind us not to equate age with staidness. Emotions, too, can be portrayed eloquently. The picture on the opposite page expresses love as powerfully as any image of a young honeymoon couple could. The close cropping of the image wastes nothing; and yet the color of the man's lined face – sharply revealed by the strong sun – finds an echo in a blur of autumn leaves in the background. Such pictures are effective because they challenge our preconceptions about older people.

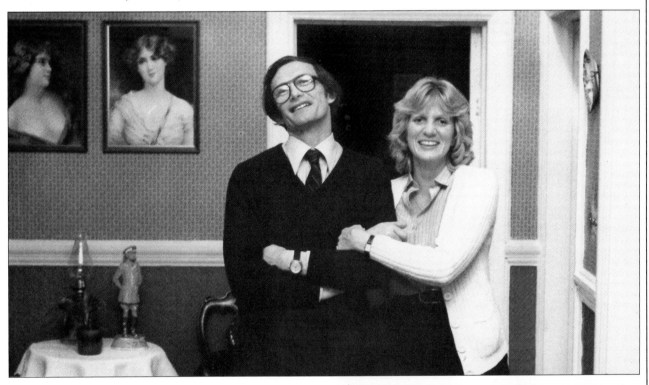

Parents tend to relax in the familiar surroundings of their home, and to react delightedly to the picture-taking efforts of their own children. This couple's son caught them perfectly.

An affectionate hug (left) and the man's response seem to encapsulate a lifetime of love in this study of a weatherbeaten couple. The picture's strength lies in its spontaneity and its absolute economy.

A sense of unabated fun shines from this picture of a trim grandmother. The soft, diffused light that filters through the leaves flatters the subject's silver-gray hair and rosy skin tones.

The family pets

No complete record of the family will leave out the much-loved pets. Animals can make fine and particularly appealing pictures in their own right – certainly in the eyes of their owners. And the inclusion of pets in pictures of people often provides a center of attention or amusement that helps spontaneity.

However, pets can be more difficult to photograph than you might expect. They tend to move off just as you are about to press the shutter release. And when they do settle, they often seem to choose a place that is visually unsatisfactory or poorly lit.

How can you persuade them to pose for photographs? A useful tip is to remember that most pets respond to food and warmth, as well as to the affection of their owners. Thus, if you want an action shot of a dog, you can plan the picture easily by having someone hold the animal a few yards from a bowl of food. Focus the camera on the space between the dog and the bowl, set a fast shutter speed, then take the picture as the dog is released.

You can use a similar subterfuge to convey the closeness between two pets. For example, a drop of

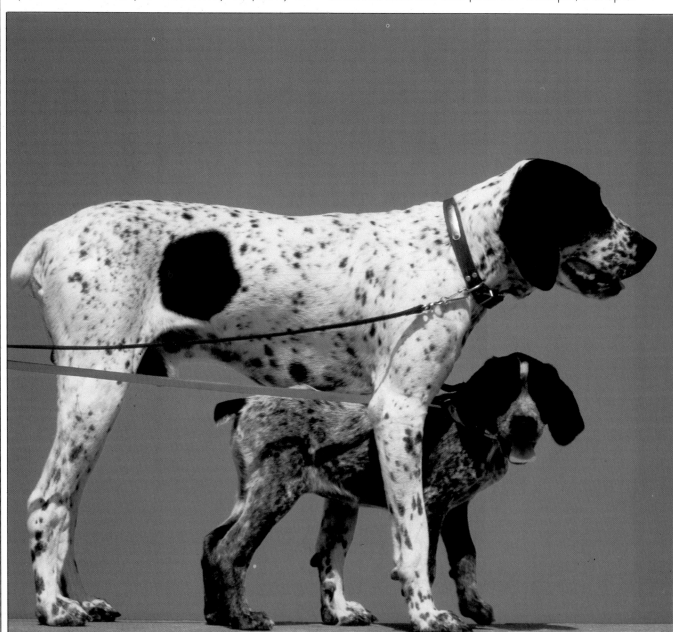

milk on the ear or face of a kitten will be invisible, but the eager lick of the kitten's mother will appear convincingly attractive. To persuade cats or kittens to stay put for a shot, conceal a hot-water bottle under a favorite blanket – the warmth will keep them in place for a succession of delightfully langorous poses. Try to get fairly close when photographing pets – for example, by using a telephoto lens – so that the animal more or less fills the frame. But be careful when using a flash unit – the sudden light may disconcert or frighten your pet.

Canine friends strike an amusing double-decker pose. The photographer got low so that the sky would fill the background with plain color, contributing a simplicity that concentrates attention on the dogs themselves.

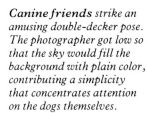

A dog's face peers eagerly at the camera, framed by the balustrade pattern. The photographer placed the pet on the balcony, took up the camera position and whistled.

A boy and his birds make a charming ensemble. Close vertical framing with the strong light coming from a door to the left, creates a bold and uncluttered record of a strong relationship.

People reflected

Few of us can pass by a mirror without sneaking at least a sidelong glance at it. The motivation is not just vanity; reflections have a special, almost magical fascination. In photographs, reflected images can add mystery, or make us feel that we are seeing in more than two dimensions. A mirror may show a second, subtly altered view of the same face, or reflect someone who would not otherwise appear in the picture – perhaps even you, the photographer, whether deliberately or by mistake.

Focusing the lens for a picture that includes a reflection needs extra care. Seemingly, the reflection must lie physically on the same plane as the mirror, but in fact the light has to travel from the subject to the mirror and back to the camera. Thus, you must focus as if the mirror is a window through which you are looking at the reflected image. For example, if you were focusing the scene below with an SLR camera, you would see different parts come into focus as you turned the focusing ring to move the lens outward. First the girl's reflection would be sharp, then the mirror frame, and finally the girl herself, seen directly.

To keep all three images sharp in this kind of situation, set a small aperture and focus on the mirror frame. But if you want to blur the subject, as the photographer did here, set a wide aperture to reduce depth of field to the minimum, and focus only on the reflection.

A mirror is just one of many sources of reflected images. Outdoors, reflections in calm water or polished surfaces can make pictures of friends look novel and arresting. These naturally occurring reflections are strongest when the shiny surface is in shadow and bright light falls on the reflected subject. The mirror image is clearer, too, if you aim the camera at the reflecting surface from an oblique angle rather than directly. The picture here of a child looking in a store window with wide-eyed wonderment demonstrates this technique.

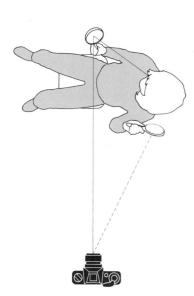

Focusing reflections
In the diagram, the red line shows the distance that light traveled to the lens from the reflected subject in the picture at right. The photographer focused on the reflection but used a wide aperture to blur the image of the actual girl, adding to the soft-focus effect by placing a diffuser over the lens. For the whole subject to be sharp, a smaller aperture would be needed. To focus accurately on a reflection without an SLR or range-finder camera, measure the distance from camera to mirror to subject.

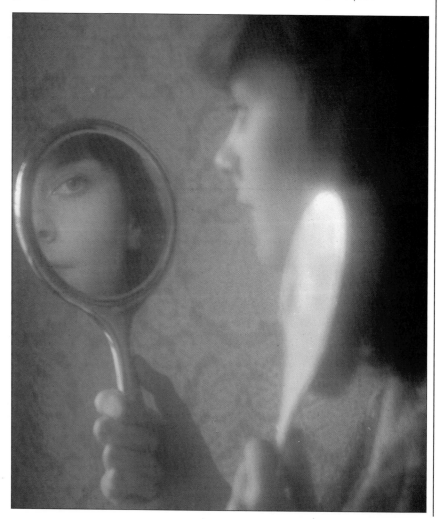

Entranced by the display in a store window, a youngster leans forward to provide a perfect reflection. The photographer made the glass serve a dual purpose: revealing the object of the child's interest and at the same time redoubling his wonder.

A mirrored profile shows two views of the same face. The photographer wanted the backlit outline of the face to be sharp, and so focused on that rather than on the reflection – knowing that the f/2.8 aperture would give only shallow focus. The light source was a single ordinary light bulb, placed behind the girl's head and out of view from the camera position.

Shiny sunglasses, like other convex reflective surfaces, form a wide-angle view of the surroundings. To achieve the result at left, the photographer asked his friend to stand in the shade, where she had a clear view of the sunlit scenery around her. Using a small aperture – f/16 – both the face and the reflection are sharp.

A touch of humor

The element most often found in pictures that make us laugh is sheer incongruity. Street signs can be funny depending on what is happening near them – for example, a pneumatic drill at work beside a sign reading QUIET PLEASE. Because a photographic image is so selective, such unexpected juxtapositions tend to look more humorous in pictures than in real life. There is nothing particularly amusing about the scene below, showing a couple embracing in Venice, until you notice the statue behind them.

Often you can use the camera's ability to trick the eye and make viewers slightly uncertain about what they are seeing – so that they do a double-take. Just what is happening in the picture of the child and the paint can opposite? Camera angles can be amusing, too, as in the photograph here of a naked child on his father's shoulders – a miniature replica. You cannot plan such a picture. But you should be on the alert for visual jokes, and ready to seize opportunities when they arise.

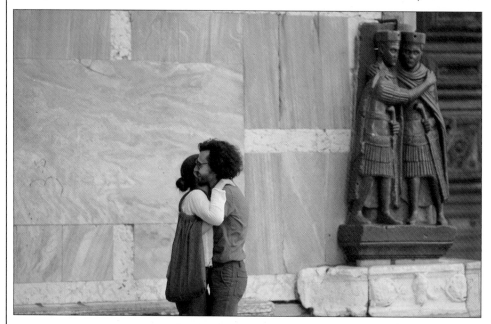

An embracing couple echo the pose of the ancient relief statue behind them. Such pictures need a sharp eye and fast reactions. The photographer's friends in the picture were unaware of the joke they were helping to make, and held the pose for only a second.

A piggyback ride produces a humorous repetition: two naked bodies that are almost identical from this angle, yet totally different in scale.

Painted statues – *in fact an illusionistic wall painting* – *made possible this deliberate visual joke. The photographer asked the child to pretend to hold the painted brush.*

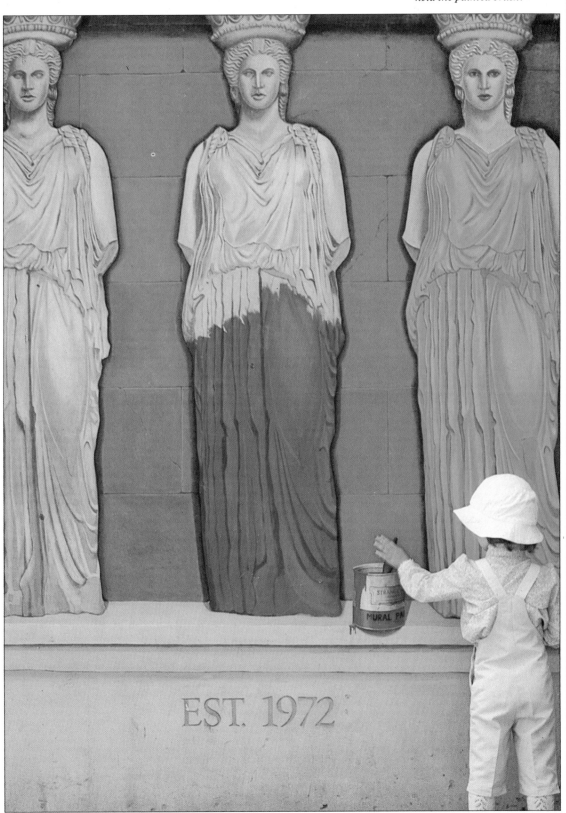

Unusual approaches/1

One marvelous thing about photography is its ability to surprise. Therefore, if you have a friend or a family member as a willing model, take the opportunity to experiment. People can be the starting point for some really adventurous photographs, as the examples on these pages show.

A portrait need not follow the convention that says you have to recognize the facial features of the person shown; the faces are shaded or hidden in the two studies below. But both pictures express something about their subjects, and they have quite distinct moods as a result of the approaches taken. One is full of movement and excitement, the other is relaxed and nostalgic.

The picture on the left is different again, relying on an extreme close-up approach for a sultry and seductive effect. Such pictures show the photographer pursuing creative ideas by setting them up with a specific result in mind. You are more likely to achieve unusual images by taking this active approach than by passively waiting for interesting scenes to come into the viewfinder.

A swing of the head throws a girl's blonde hair in front of her face (above). With strong lighting from the side, this casts deep shadows over the face. To add to the bold, unusual effect, the girl held a dark cloth in front of her body. A shutter speed of 1/500 was fast enough to freeze the movement of the hair.

Red lips dominate this extreme close-up of a face (left). The photographer moved strands of the girl's hair across her face to deepen the sense of mystery. A macro lens, close-up attachment or extension tube is necessary to come in this close.

A girl in a hammock makes a timeless image, redolent with the laziness of long, late-summer afternoons (right). The photographer composed the shot with great care, pulling the girl's hat down over her face and draping her arm down to make a bold line.

Unusual approaches/2

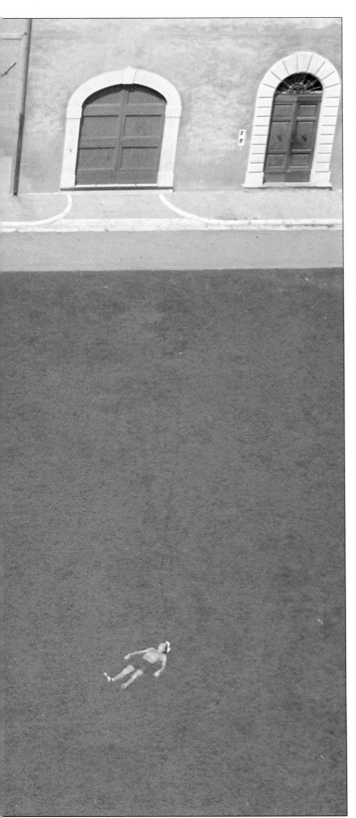

The creative photographer sees beyond obvious interpretations of the subject. Of course, you should first take the pictures of your friends or family that they will expect to see, in which they are clearly visible and dominate the frame. But after you have these shots safely in the camera, explore other possibilities. Often, odd ideas that you are not quite sure about – ideas that you may think of as creative footnotes to your main pictures – will be most memorable. The failure rate may be high, but you will be proud of the pictures that work.

In one of the two photographs here, the person being photographed is only a tiny spot in the frame, and in the other, nobody can be seen at all. Yet for those who were present, both pictures would evoke precise memories. And for others, they provide intriguing and unusual images.

A sunbathing tourist lies dwarfed on a vast lawn. His more active friend, looking down from a balcony, took the picture as an amusing composition, using a slightly wide-angle lens.

Gone for a paddle, the owner of these shoes and socks still seems present. The tightly framed picture sums up a day on the shore more neatly than a straight shot of the child would.

Using movement

A good likeness of somebody you know well usually means a sharp picture of the person sitting or standing still. But if the subject is a dynamic person who rarely keeps still for a moment, how accurately can a static picture reflect the personality you want to show? For a more natural effect, try making movement an integral part of the picture.

Children, who are constantly in motion, especially invite this treatment – and the picture at near right shows how successfully you can capture their vitality. By waiting until the little girl reached the zenith of her bounce, high above a trampoline, the photographer caught a frozen image that clearly expresses the child's exhilaration.

Such activities, which have motionless peaks in the action, are easy enough to freeze on film, but perfect sharpness is not always necessary or even desirable. A slightly blurred picture can suggest people's movements just as powerfully. The impression of motion is all the more realistic if you use a panning technique to produce sweeping background lines emphasizing the direction in which your subject is moving. To achieve this, use a slow shutter speed – two examples are given in the captions to pictures here – and move the camera during exposure to follow the movement of the figure. The picture on the opposite page shows that you need not restrict yourself to horizontal movement in expressing other kinds of activities. Here, the photographer deftly turned the camera with a twist of the wrists during exposure to express the giddy motion of a child's somersault.

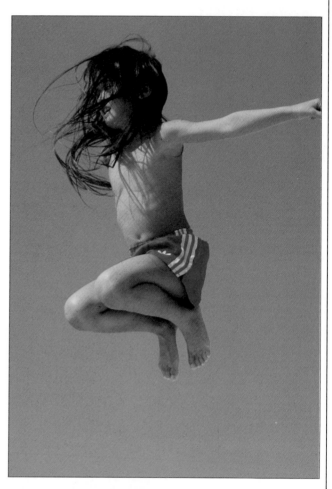

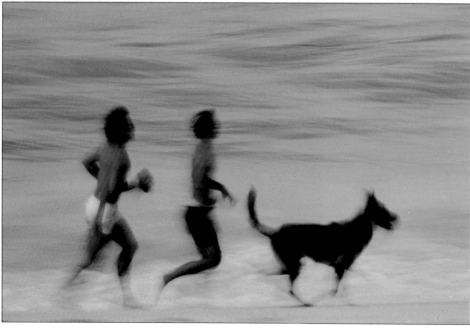

A high flier launches herself from a trampoline (above). The photographer chose a low position, to outline her figure clearly against the blue sky and used a speed of 1/500.

Racing on a beach, two friends and their dog (left) begin to dematerialize as they move faster than the camera – panned at a shutter speed of 1/8. The blurring gives a vivid impression of their gathering speed.

The whirl of an entire somersault seems captured in the picture opposite – an effect achieved by quickly turning the camera during an exposure of 1/4.

Glossary

Aperture
The opening in the lens that admits light. Except in very simple cameras, the aperture can be varied in size to regulate the amount of light passing through the lens to the film.

Available light
The existing light (natural or artificial) in any situation, without the introduction of supplementary light (for example, flash) by the photographer. The term usually refers to low light levels, for example indoors or at dusk.

Backlighting
A form of lighting in which the principal light source shines toward the camera and lights the subject from behind.

Bounce flash
A technique of softening the light from a flash source by directing in onto a ceiling, wall, board or similar reflective surface before it reaches the subject.

Close-up lens
A simple one-element lens, placed over a normal lens, in the same way as a screw-on filter, allowing the camera to be focused closer to a subject.

Cropping
Trimming an image along one or more of its edges to eliminate unnecessary parts, or framing a scene to leave out parts of a subject.

Depth of field
The zone of acceptable sharp focus in a picture, extending in front of and behind the plane of the subject that is most precisely focused by the lens.

Diffused light
Light that has lost some of its intensity by being reflected or by passing through a translucent material.

Exposure
The total amount of light allowed to pass through a lens to the film, as controlled by both aperture size and shutter speed. The exposure selected must be tailored to the film's sensitivity to light, indicated by the film speed rating. Hence overexposure means that too much light has created a slide or print that is too pale. Conversely, underexposure means that too little light has resulted in a dark image.

Extension attachment
Camera accessory used in close-up photography to increase the distance between the lens and the film, thus allowing you to focus on very near objects. Extension rings are metal tubes, usually sold in sets of three, and can be used in different combinations to give various increases in lens-film distance. Extension bellows are continuously variable between the shortest and longest extensions. These are more cumbersome than tubes, and need to be mounted on a tripod.

Fall-off
Deterioration in the intensity of light as distance from the light source increases.

Film speed
A film's sensitivity to light, rated numerically so that it can be matched to the camera's exposure controls. The scales used formerly, ASA (American Standards Association) and DIN (Deutsche Industrie Norm), are now superseded by the system known as ISO (International Standards Organization).

Filter
A thin sheet of glass, plastic or gelatin placed in front of the camera's lens to change the appearance of the picture.

Flash
A very brief but intense burst of artificial light, used in photography as a supplement or alternative to any existing light in a scene. Batteries supply the power to most flash units. Some small cameras have built-in flash, but for most handheld cameras, independent flash units fit into a slot on top of the camera.

Focal length
The distance, usually given in millimeters, between the optical center of a lens and the point at which rays of light from objects at infinity are brought to focus. In general, the greater the focal length of a lens, the smaller and more magnified the part of the scene it includes in the picture frame.

Lens
An optical device made of glass or other transparent material that forms images by bending and focusing rays of light. A normal lens produces an image that is close to the way the eye sees the world in terms of scale, angle of view and perspective. For most SLRs the normal lens has a focal length of about 50mm. A wide-angle lens (for example, 28mm) takes in a broader view of a scene than does a normal lens, and a long-focus or telephoto lens (for example, 135mm) shows a smaller area on a larger scale. A zoom lens is variable in focal length. For example, in an 80mm – 200mm zoom lens, the focal length can be changed anywhere between the lower limit of 80mm and the upper limit of 200mm. With a zoom, a photographer can reduce or enlarge the scale of an image without throwing it out of focus.

Panning
A technique of moving the camera to follow the motion of a subject, used to convey speed or to freeze a moving subject at slower shutter speeds. Often, a relatively slow shutter speed is used to blur the background while panning keeps the moving object sharp.

Red eye
The bright red color of the pupil of the eye that sometimes disfigures pictures taken by flash. It is caused by reflection of the flash unit's light from layers of the retina rich in blood vessels. Red eye can be avoided by making sure the subject is not looking directly at the camera or by using off-camera or bounce flash.

Reflex camera
Any camera that uses a mirror in the viewing system to reflect the image to the viewing screen. The most common type is the single lens reflex (SLR), which uses a hinged mirror that flips out of the light path when the film is being exposed. The image that appears on the viewing screen, just before the exposure is made thus shows what will appear on the film, whatever the lens used. In a non-reflex camera, the lens that views the subject is different from the one that exposes film. This is true also of the twin lens reflex (TLR), which has two identical lenses mounted one above the other.

Rimlighting
A form of lighting in which the subject appears outlined with light, against a dark background. Usually, the light source in rimlit pictures is above and behind the subject.

Shutter
The camera mechanism that controls the duration of the exposure.

Sidelighting
A form of lighting in which light falls on the subject from one side. Sidelighting produces dramatic lighting effects, casting long shadows and emphasizing texture and form.

SLR see REFLEX CAMERA

Soft focus
Deliberately diffused or blurred definition of an image, often used to create a dreamy, romantic look in portraiture. Soft-focus effects are usually created with special lenses or filters.

Index

Acknowledgments

Picture Credits
Abbreviations used are: t top; c center; b bottom; l left; r right.
Image Bank is abbreviated as IB.

Cover Marcel Chassot

Title Michael Boys/Susan Griggs Agency. **7** Brian Seed/Click/Chicago. **8-9** Walter Imber. **10** John Garrett. **10-11** John Garrett. **12** l Krishan Arora. **13** Cecil Jospé. **14** Lise St Denis. **14-15** Mike Harker/IB. **16-17** Peter Thompson. **18** l Herbie Yamaguchi/Xenon, tr Didier Derambur/ fotogram, br John Sims. **19** Walter R Gyr. **20-21** Francoise Bouillot/ Kodak. **22** t Geg Germany/Daily Telegraph Colour Library, b Homer Sykes. **23** tl Francoise Bouielot, tr Kim Olsen, b Linda Foard. **24-25** Mike Burgess. **26** Graeme Harris. **27** All Barry Lewis/Network. **28** t Kodak-Pathé, b Robert Littlepage. **29** Timothy Woodcock. **30** Jean Bar/ fotogram. **31** tl Robin Laurance, tr Brian Shuel, b Francois Darras/ fotogram. **32** Jay Freis/IB. **33** l Tim Ashley, r Digiacomo/IM. **34** l Robert Taurines/Explorer, r Guy Fleury/fotogram. **35** t William Kennedy/IB, b Don Savage. **36-37** Brian Seed/Click/Chicago. **38** Francoise Bouielot/ Kodak. **39** t Trevor Wood, b Sebastian Keep/Robert Harding Associ- ates. **40** t John Garrett, b Steve Wall/Click/Chicago. **41** David Hamilton/ Daily Telegraph Colour Library. **42** t Janice Keene, b Anne Conway. **42-43** Alain Bordes/Explorer. **44** Trevor Melton. **45** t John D Crow, b Trevor Melton. **46** l Sally & Richard Greenhill, r Tino Tidaldi. **47** t Trevor Melton, b Nancy Brown/IB. **48** tl Trevor Wood, bl r Peter Phillips/Trevor Wood Picture Library. **49** Jacques Joffre/Explorer. **50-51** John Sims. **52** T Janeart Ltd/IB, b Chantal Wolff/Explorer. **53** t Michael McCoy, b M Friedel/IB. **54** Joseph F Viesti/IB. **55** John Sims. **56** Bruce Davidson/Magnum. **57** t D Clerent/Explorer, b Angela Murphy. **58** Peter Le Grand/Click/Chicago. **59** Bill Weems/Woodfin Camp Associates. **60** John Hedgecoe. **61** l Dab Budnik/John Hillelson Agency, r John Hedge- coe. **62-63** Nancy Durrell-McKenna. **64** t Neill Menneer, b Bruce Herman/Explorer. **65** t Julian Calder, b David Redfern. **66** Patrick Bordes/Explorer. **67** Michael Boys/Susan Griggs Agency. **68** G Boutin/ Explorer. **69** t John Garrett, b Sergio Dorantes. **70-71** Barbara S Dick. **72** C Sommer/Explorer. **73** t D Sparks/IB, bl R Gunther/Explorer, br Michael Busselle. **74** Linda Burgess. **75** l Patti Jones, r Sally & Richard Greenhill. **76** l Barry Lewis/Network, r John Garrett. **77** A J Bedding/ Tony Stone Associates. **78** John Garrett. **79** l Thomas Höpker/Magnum, r Guy Plessey/Explorer. **80** l Gérald Dumour/Explorer, r John Garrett. **81** D Brownwell/IB. **82** Brian Shuel. **83** Graeme Harris. **84** Nikita Kolmikow. **85** t Nikita Kolmikow, b J Tisne/Explorer. **86** Martine Wintz/Kodak. **87** tl Audrey Stirling/Daily Telegraph Colour Library, tr Anthony Howarth/Susan Griggs Agency, b Sally & Richard Greenhill. **88** Wayne Miller/Magnum. **89** b Bard Martin/IB. **90-91** André Chastel/ Kodak. **91** t Adam Woolfitt/Susan Griggs Agency, b Reg Cowderoy. **92** Anne Conway. **93** t H Valler/Explorer, bl Spectrum, br Gene Lincoln/ Spectrum. **94** t Brian Seed/Click/Chicago, b John Garrett. **95** Linda Burgess. **96** Oliver Garros/fotogram. **97** l Richard Kalvar/Magnum, r Graham Finlayson. **98-99** John Sims. **99** Barry Lewis/Network. **100** t Bruce Herman/Explorer, b Al Satterwhite/IB. **101** Gary Gladstone/IB.

Artist Andrew Popkiewicz

Retouching Roy Flooks

Time-Life Books Inc. offers a wide range of fine recordings, including a *Big Bands* series. For subscription information, call 1-800-621-7026, or write TIME-LIFE MUSIC, Time & Life Building, Chicago, Illinois 60611.

Notice: all readers should note that any production process mentioned in this publication, particularly involving chemicals and chemical processes, should be carried out strictly in accordance to the manufac- turer's instructions.

Kodak, Ektachrome, Kodachrome and Kodacolor are trademarks Printed in U.S.A.